D1083231

CONCILIUM

Religion in the Eighties

CONCILIUM

Concilium 132 (2/1980): Liturgy

SYMBOL AND ART IN WORSHIP

Edited by

Luis Maldonado
and
David Power

English Language Editor
Marcus Lefébure

T. & T. CLARK
Edinburgh

THE SEABURY PRESS
New York

BX
880
.C7
vol. 132

February 1980

T. & T. Clark Ltd., 36 George Street, Edinburgh EH2 2LQ
ISBN: 0 567 30012 9

The Seabury Press, 815 Second Avenue, New York, N.Y. 10017
ISBN: 0 8164 2274 5

Library of Congress Catalog Card No.: 80 50 423

Printed in Scotland by William Blackwood & Sons Ltd., Edinburgh

Concilium: Monthly except July and August.
Subscriptions 1980: All countries (except U.S.A. and Canada) £23·00 postage and handling included; U.S.A. and Canada $54.00 postage and handling included. (Second class postage licence pending at New York, N.Y.) Subscription distribution in U.S. by Expediters of the Printed Word Ltd., 527 Madison Avenue, Suite 1217, New York, N.Y. 10022.

CONTENTS

Editorial vii

Part I
Articles

Art in the Liturgy
 LUIS MALDONADO 3

The Content of Eastern Iconography
 CONSTANTIN KALOKYRIS 9

Gestures, Symbols and Words in Present-day Western
Liturgy
 ADRIEN NOCENT 19

The Politics of Symbol and Art in Liturgical Expression
 AIDAN J. KAVANAGH 28

Christian Art of the Oppressed in Latin America
 ENRIQUE DUSSEL 40

Freedom of Bodily Expression in the African Liturgy
 BOKA DI MPASI LONDI 53

Part II
Bulletins

Symbols in Christian Worship: Food and Drink
 CYRILLE VOGEL 67

Unofficial Eucharistic Prayers: An Appraisal
 JEAN-PIERRE JOSSUA 74

v

What has Literature to say to Liturgy?
 MICHAEL PAUL GALLAGHER 84

Image, Culture, Liturgy
 CRISPINO VALENZIANO 91

Liturgical Music after the Second Vatican Council
 BERNARD HUIJBERS 101

The Rediscovery of the Role of Movement in the Liturgy
 A. RONALD SEQUEIRA 112

Contributors 120

Declaration of Concilium 123

Editorial

THE THEME of this issue of *Concilium* consists of two distinct but closely related subjects—liturgical expression and beauty or art in the liturgy. Since these subjects are so inter-related the dangers of false aestheticism, mere structuralism, empty formalism and a biased psycho-sociological understanding of the liturgy can be avoided.

From the outset, the great tradition of Eastern Christianity directs us towards a perception of beauty that is specifically based on the gospels (Kalokyris). What we are dealing with is the expression and experience of holiness, the transfiguration of Christ, and, through Christ, the transfiguration of the whole of creation, without ignoring the actual moment of salvation history in which we live—our situation in the eschatological 'meantime'.

The practising Christian's concept of beauty which the liturgy tries to express comes to him by way of the cross and the resurrection. Perfect beauty is the beauty of God's face in man, the icon of the risen Christ which has already been the disfigured, reviled and wasted Face of the Servant of Yahweh, the Holy Face sketched by Isaiah; 'he had no form or comeliness that we should look at him' (Isa. 53:2).

The glory of the resurrection shines from a face which has achieved the highest perfection through suffering. St Cyril tells us that the temporal dimension of the incarnation and the passion gradually formed the beauty of the Son of God; the beauty of a bloodied but resurrected Face, which, through death, conquered death itself. Through His tears, and without beauty according to worldly standards, the Man of Sorrows reveals Himself as the Transfigured Christ (O. Clement).

In this way, the apparent irreconciliability of art and Christian liturgy is overcome and to a certain extent resolved despite the dialectic intransigence of some who would maintain otherwise.

However, another practical approach towards overcoming any such irreconciliability is suggested by several of these articles—namely, the elimination of all élitism which creates privilege of any kind within the Church's worship.

History shows us that a certain Roman respect for privilege coupled with an endemic poverty of visual appeal has been the cause of the unfortunate dichotomy which appears so frequently in the Catholic West between an 'official' and a 'popular' liturgy (Nocent). The results of this dualism are well known; an ever-growing intransigence, an increasing

abandonment of rubrics, a gradual deterioration of what is genuinely popular in favour of devotionalism and 'folklore' and an aggressive resentment towards established structures.

The Second Vatican Council's emphatic statements on the Church as the People of God, the priestly participation of the people in the Church's worship and the use of vernacular languages in the liturgy have brought about vast changes with consequences which we still cannot assess. Respect for privileged positions and the aesthetic tastes of a minority are increasingly being replaced by a liturgy which is 'popular' in the fullest meaning of the word; viz., not just in the theological but also in the sociological sense.

Art, expression and symbol can begin to reflect the struggles, incidental difficulties and the destitution of people, but, given the tensions that exist, it is very difficult to create unifying links of sensitivity, symbolism and aesthetics which reflect the faith of all—a faith which conquers divisions and at the same time looks forward eschatologically, and not 'ideal-istically' to reconciliation (Kavanagh).

Aesthetics cannot ignore ethics. There is an aesthetics of domination and an aesthetics of liberation and Christian aesthetics has no choice but to opt for the latter. There is an art that properly belongs to the oppressed—the popular art created by the working classes—and an art that belongs to the prophetic vanguard of Christianity. Both kinds belong to the category of art of liberation and find their privileged 'locus' in the celebration of the Eucharist (Dussel).

However, if the liturgy is to be really a successful and complete ex-pression of the faith, as its nature demands, it has to be already, here and now, a liberation *in actu* to the extent that through it man achieves personal harmony, is completed and is reconciled with himself, with God and with his neighbour. This integration, reconciliation and har-monisation at all levels of the human person, but especially of his body, soul and spirit, are features of other cultures and civilisations which the Roman liturgy has so far chosen to ignore, but which can make a sig-nificant contribution to its renovation.

A creative vitality, a feeling of bodily sharing and participation, dance as an expression of the depth and intensity of one's feelings as well as an expression of contact with mystery through the uninhibited and liberating use of one's body are sure manifestations of what constitutes liturgical expression (Boka Londi).

The liturgy makes use of words, symbols, images, songs and move-ments, and dancing can be a means of worshipping God (Sequeira). Song and music are essential elements in the liturgy's expressiveness (Huijbers).

Liturgical symbols are numerous and their use in the post-conciliar

liturgy has to be increased—the most important of these is the sacred meal. Given the numerous contemporary experiments and attempts to give new life to the celebration of the Eucharist (both as a community and a festival celebration), it is important to realise once again both the relationship and the distinction between a satisfying meal, a sacred banquet and the celebration of the Eucharist (Vogel).

Along with symbols, corporal movements, song, etc., there is no doubt that the word is the fundamental means of expression in the Christian liturgy. The Council has made a very serious effort to re-direct the Church's liturgy towards becoming a more evangelical-prophetic liturgy. The value of this aspect of the liturgy cannot be argued away.

The word of prayer is the liturgical response to the word proclaimed and listened to by the community as the living revelation of the personal God who reveals himself in history. And since a very special form of the word of prayer is the Eucharist Prayer, it is specially important that the texts in use today should be carefully studied. Here, there arises the problem of the tensions between what is official and what is creative, between what is institutionalised and what is freely inspired. Creativity, however, is not the kind of improvisation that can follow a moment of enthusiastic euphoria, supposedly aroused by the Spirit. True creativity always follows subtler lines, like the threads of a cloth woven patiently by tradition; in this sense, true creativity has the character of *midrashic* or Targumic glosses, the results of a practical re-reading of ancient and venerable texts.

One thing that has to be considered above all is the form, literary value and poetic beauty of a liturgical text. To be truly beautiful and poetic a word has to be a faithful reflection of real life. It must not be in any way an imitation of literacy *clichés*—simplicity and constraint must be its hallmarks (Jossua).

Liturgical texts must avoid utilitarian, mediocre and trite language, and expressions which have been rendered trivial through over-use or propaganda. The literary style of liturgical texts must attempt to demand attention, readiness and receptivity at a deeply spiritual level. Every aesthetic experience tries to awaken the spirit of man and sustain his attention; the texts used in the worship of God must try to do the same.

The development of ideas and concepts within the liturgy, must be enriched by stories, parables, symbolism and imagery. Thus, narrative and evocative forms must take precedence over the purely conceptual forms of discourse. The flexibility and interplay of a variety of style and language can be of great benefit in a liturgical celebration which moves at varying rhythms and uses a wide variety of liturgical texts (Gallagher).

Contemporary popular culture makes use of literary images (the 'image' word), liturgical symbols and 'iconic' imagery and the inter-

relationship of these creates many problems for their use in liturgical worship. One fundamental criterion for recognising and safeguarding the specific nature of the liturgical image (be it literary or plastic in the two-dimensional or three-dimensional sense) is that of communal participation. Anything that smacks of or creates passivity, inactivity or a lessening of one's personal transaction with the community is anti-liturgical or aliturgical (Valenziano).

LUIS MALDONADO
DAVID POWER

Translated by John A. Macdonald

PART I

Articles

Luis Maldonado

Art in the Liturgy
(A Theological Meditation in Response to an Ecumenical Essay by Olivier Clement)

THE REFORM of the Roman Liturgy by Vatican II has inspired many communities to try and create liturgical celebrations which are based on the gospel and also proclaim the Good News of salvation. Accordingly, this kind of liturgy would have to use the resources of the poverty recommended by the beatitudes and be creative to the extent that it would encourage spontaneity.

These good intentions have been fruitful, but have also created problems. Lack of vision, and inexperience of authentic evangelisation and creativity have brought into being a kind of mutilated liturgy; a liturgy which is devoid of true expressiveness because it lacks the most basic form which is artistic expression. Proclaiming and celebrating the faith in the liturgy can be ineffective if the liturgy itself does not touch the inner depths of man, and this can only be achieved through some form of aesthetic experience. Artistic expression is never the fruit of spontaneity but of genuine creativity which implies a long period of gestation and the search for adequate structures. Because creativity has often been confused with improvisation, an inadequate, impoverished and frustrating form of liturgy has come into being.

This issue of *Concilium* is intended to contribute towards clarifying some of these points. While it was in the process of preparation, *Le Visage intérieur* by Olivier Clement was published and this has been my 'book at bedtime' as I have been thinking over this subject.

When we turn to the Eastern Christian Churches and consider how they have dealt with these problems, we discover that their sensitivity to artistic expression and the way they deal with it in the liturgy have been very successful and is remarkably relevant to our situation in the West. It is well known that a variety of new liturgical experiments, by Catholics

3

and Protestants alike (e.g., the Community of St Gervais in Paris and the accounts in *Seduction of the Spirit* by H. Cox respectively), find their inspiration in the Byzantine liturgy.

O. Clement's work, however, is not just the fruit of Eastern Orthodox inspiration but also derives from the very heart of Western European culture. This dual genesis of his thought creates a favourable atmosphere for ecumenical dialogue. A look at some of his observations, intuitions and conclusions will provide a suitable synthesis in which to consider the theme of this issue of *Concilium*.

A basic expressive ingredient of liturgical tradition is the spoken word and it has to be included in liturgical celebration in a totally artistic context as a way of preparing the senses for experiencing the beauty of the sacred. Moreover, the liturgy has always tried to use art to integrate time (through music and poetry) and space (through painting and architecture). And, in addition, all the material elements of a liturgical celebration, e.g., the smell of incense, shining lights, hymns, images, are symbols of heaven and earth united in the body of Christ through the Holy Spirit.

Through our bodily perceptions, the liturgy makes us spiritually receptive. Its beauty reaches beyond our normal perception of beauty because it comes to us through the cross and resurrection. Furthermore, it is full of silence and light.

A consideration of some of the artistically expressive elements in the liturgy will help us discover their significance for theology and for pneumatic-Christology in particular.

After the Conciliar reforms, there should be no doubt that the spoken word is the principal expressive element in the liturgy, and while it is much used it is also abused. Thus a balance has to be struck by restoring to the word its corresponding polarity of silence. Silence can be equally expressive if properly understood as the antithesis of the spoken word; thus, it is not merely the absence of speech but also expresses completeness, intensity and the brimming-over and ineffable nature of experience.

The binomial reality word-silence, as a dialectic of expression, is not a purely formal or psychological entity because, despite its merely formal appearance, it has a real foundation in theology and is rich in content. In the very depths of its being, the spoken word has its corresponding reality in the Word made flesh just as silence has its complement in the Spirit. Word and silence have their roots in the Trinitarian reality of the relationship between the Word and the Spirit. The Spirit is the breath of the One who bears the Word; it is the silence of the One in the heart of the Word.

The Holy Spirit has no proper name (qua relationship), and no feast-

day or specific prayers. In the activity of the Trinity, *ad extra*, the Spirit hovers over the primeval waters as a bird rests over its brood to provide them with shelter and warmth; this is the 'cosmic Pentecost' which makes all things open to the influence of the Word of God who speaks to us in everything; his words are the *logoi spermatikoi*.

Faith, as a personal commitment to God's self-revelation of his hidden presence which allows us to participate in his sanctifying vitality and as an encounter of joy, of fire and of dazzling light is a kind of 'implosion' of silence. Man is rendered speechless and his silence becomes totally expressive; full of the joy of the Spirit, his experience evolves into a celebration.

The Fathers of the Church tell us that we have to 'breathe the Holy Spirit' and the breath of God, which is the Spirit, thus unites with our own physical breathing. The receptive silence which is the fruit of the Spirit's influence becomes fertile ground for meditation which is the natural complement to liturgical prayer. And it is this kind of meditation which the East is offering us today—a prayer in time with our breathing, the circulation of our blood and all the other natural rhythms of our bodies.

Accordingly, in some communities, liturgical celebrations are preceded by half an hour of silent meditation and even the nave of the church is left free so that prayer may be said in a variety of postures.

One special form of rhythmical and corporeal expression is dancing which once again is being used in the liturgy to complement the spoken word within terms of the pneumatology already mentioned. The psalmist says: 'Let them dance in praise of His name' (Ps. 149:3).

Silence saturates the word but does not absorb it just as the Spirit reposes in the Word eternally and acts in the incarnation and in the deifying transfiguration of Christ's humanity. Moreover, silence is neither anterior or posterior to the word itself but is its very essence.

In the liturgy, silence can also be present through poetry and music—aspects of the temporal dimension of art which forms part of the total and integral art of the liturgy. Liturgical singing can be especially important and useful in this sense as it disposes the word towards silence and directs it towards mystery.

The rhythm of singing and music breaks the autonomy of speech, reveals the mystery therein contained and is a catalyst for the silent music of the body; in this way, it reaches man's heart—'that other body in the very depths of our being'. It is precisely here, in this 'inwardness' of body, heart and silence, that symbols and images become meaningful to form the poetry that unites heaven and earth.

Music takes away the purely conceptual element from the words of a song and through sound makes them produce their own most fascinating and enchanting effects.

When the spoken word becomes liturgical song it creates a fusion of antinomy and symbol. I refer to the antinomy of inaccessible mystery and the divine 'philanthropy'; the antinomy of the infinite which allows itself to be limited and defined and that of the incomprehensible which wants to be understood.

The dynamism of this antinomy demands that the structure of songs be symbolic. This symbolism can represent the 'wonderful deeds' of God in salvation history or be the cosmic symbolism which reaches its fullest significance in the transfiguration. The burning bush then becomes an image of the mother of God, sign of the earth on which light has been cast—the land of those living in Christ and his Eucharist. Water becomes the water of death and resurrection. The three elements of fire, wind and living water represent the Spirit, which, in the Eucharist, gives life to the dead earth. Finally, the Cross, prefigured by the tree of Paradise, the ark of Noah, and Jacob's ladder, becomes the new tree of life which for ever unites what is created with what was not created.

This last point is more relevant to sacred song as a text and is specially applicable to liturgical poetry which is an important form of expression neglected at the moment in the liturgy. Apart from the psalms, there is a very serious lack of lyrical texts and hymns in the present Roman Missal, while there is a vast quantity of poetic texts which are used in the Byzantine liturgy especially when the office forms part of the celebration of the Eucharist.

An important source of material to meet this need could be the corpus of liturgical poetry created between A.D. 500 and 1000 not just in the East but also in the West, and which can still be of use today. The renewal of liturgical poetry which has just begun will be unsuccessful if it does not follow the living traditions initiated by the Fathers of the Church.

It is very significant that monasteries are the cradles of the best hymn composition and liturgical experiments in the West as well as in the East. Perhaps we could note that the traditional desert situation of the monastery has been replaced by the urban desert of our vast cities today. The most favourable environment for the creation of liturgical texts, especially the poetic ones, is that of long and patient prayer and regular meditation.

Within the spatial dimension of art which completes the context of total and integral art in liturgical celebration, pictorial art makes a special contribution towards uniting liturgical and aesthetic experience. Painting unveils the mystery of things in the scrutiny of light and it does so, not by creating 'another world' but by showing up the intensity of what is real, the density of things, that which makes them what they are; art expresses the truth of things and their peace in being. Art does not attempt to create an external similarity but to make known the secret nature of things,

which manifests and hides itself in a continual process, this is the secret of appearance.

We can recall here the word used in Genesis to describe things when they were created: *tob*. It means real, beautiful, and good; and the same can be said of the biblical Greek word *kalos*. The painter sees and allows us to see that a particular thing is real, beautiful and good. He enters into things and causes things to reveal their true being. For their part, things open out to the artist so that the painter and the world have a kind of nuptial relationship.

The ancient Greek concept of the world of things corresponds to this process of pictorial art. The *physis* is what makes itself manifest in the mystery; it appears but never fully manifests itself. The earliest Byzantine aesthetics which inspired the builders of Sancta Sophia used the *techné* for a similar purpose. Artistic technique is a form of procreation, a bringing to life and a giving birth which reveal the secret beauty of things. Thanks to the artist, matter and the materials used become beautiful partners, and then fertile mothers who produce children of light.

The painter, and the plastic artist in general, knows how to live in silence till he experiences the world around him not just as a body of flesh but also as a clothing of light. He also discovers that his body is not limited by its 'tunic of skin' but is interwoven with the wind, the sun, the rocks and the clouds. The same perceptions can come to us if we enter into communion of contact with the artist's work. We feel that our bodies are made of light and can reach the furthest corners of the earth. Man, the prisoner of haste and eagerness, can only capture what is momentary and useful. The painter teaches us to see. And helping us to see is helping us to slow down and capture the present both as an instant of eternity and as a free gift. He helps us to perceive something which is beyond us, not in the sense of being 'of another world', but as being the revelation of being itself; the secret of things revealed in light.

In real terms, iconic art shows that the incarnation really took place in matter, that it has lightened up the secret depths of matter and restored to matter its fundamental sacramentality. In Christ, matter has become 'spiritual'; it has become impregnated with the 'powers' of the Spirit. Thus, the face of man becomes a sacrament of beauty. An icon tries to express 'the ineffable beauty of the luminous glory of the face of Christ', and the Spirit's participation in that light.

What constitutes the very essence of beauty is the light which is Christ; the Christ whom the Alexandrian theologians described as 'the light of light', 'enduring brilliance of the divine sun', 'splendour of the Father' and 'spreading glow of the lamp of the sun'. The Alexandrian theology of the fourth and fifth centuries symbolises the relationship of Christ with the Father by means of imagery of the sun's fertility.

B

Beauty is a divine attribute, a divine energy, one of the fundamental areas of God's presence in his creation, his 'ecstasy'. Through Christ, divine beauty restores human beauty in light. As one of the antiphons of the feast which celebrates the restored cult of the icon says: 'It has restored its original dignity to the image of God, and has united it to the divine beauty'. And Cyril of Alexandria comments: 'Through the beauty of the Son in time, men are brought to eternal beauty' (*Treasury* 559).

Today, more than ever, we have to rediscover the ultimate beauty which brings the breath and fire of the Spirit to us. The Spirit is the hypostasis of beauty. Absolute beauty is the beauty of the face of God in man, the icon of the risen Christ; and the beauty of the faces of men in God, the icons of the resurrected. On both the human and the divine level, on the level of the Spirit, this beauty is the 'burning bush' of the union of earth and heaven. Through the Spirit of beauty, God goes out of himself—beauty is the 'ecstasy' of God—and the earth becomes receptive, and heaven comes into being.

It has to be added that absolute beauty is inseparable from creative love. When man discovers the words of the Word made flesh in things ('The Bible of the World' or *logoi spermatikoi* of the Fathers) and when he sees the inalienable vocation of the icon in so many faces of those who have died for the faith, he becomes a person with a community dimension who takes part in the transfiguration of the earth.

Christian culture has always tried to discover and purify the mystery in things in order to free the world from its idols, magic and narcissistic illusions. And this kind of desacralisation of the world is only a step towards its transfiguration. Art, then, has to bear witness to the Spirit, imminent and becoming known in all things, for whom there is no sacred or profane but only the 'beauty of the world as an icon of God's Kingdom'; that is, the truth of things in light.

Within this transfiguring process the face becomes completely readable as the ancient aesthetes say; that is, totally and fully transparent; in addition, all things display the *splendor veri* of the definition which the ancients gave of beauty. In other words, mystery comes to the surface in the truth of all beings and things once they are freed from all opaqueness, banality and vagueness in the light whose inaccessible source is in the risen Christ.

Translated by Angus Macdonald

Constantin Kalokyris

The Content of
Eastern Iconography

1. ICONS IN EASTERN CHURCHES

FROM THE beginning, iconography in the Eastern Churches appeared as art not for its own sake, but for the Church. Thus, its content was determined directly by the needs and the profounder purposes of the Church. Faith in the spiritual reality, in the immortality of the soul and in the blessedness that is in God was primary. The believer had to be taught in every way possible that in his journey towards perfection in Christ he would have to struggle against the powers of darkness, against manifold evil, and even to reach martyrdom, as did the Saviour, the apostles, and the martyrs of the Faith. It was necessary for the Church to present these personages as examples to inspire, to guide, and to encourage the faithful. In the life of the Church there were also misinterpretations of the orthodox teaching that she followed, that is, heresies emerged. For this reason, the Church established her creed, her dogmas. For these and about these, the Church developed the higher theology. This theology was expounded and interpreted from the pulpit. But besides these dogmas, there was need (especially for the simpler folk) of other more empirical commentaries.[1]

For all these purposes, i.e., her needs and her aspirations, the Eastern Church sought the assistance of painting. So Orthodox icons of all periods answered these purposes completely. Thus, the content of the icons was interwoven with the life, the evolution, and the whole tradition of the Church.

Especially after the iconoclastic controversy and the victory of Orthodox belief regarding the icons and the official bond of Orthodoxy

with iconography (the victory of the icons was regarded for this reason as a victory of Orthodoxy and it is as such that the Sunday of Orthodoxy has been named in commemoration), the painting was characterised as dogmatic, since its content dealt with the doctrinal truths. The Pantocreator in the dome depicts at once the Father and the Son—the expression of the dogma concerning consubstantiality. The dogma of the Virgin as ὄντως Θεοτόκος (truly mother of God), formulated by the Council of Ephesus (431), was expressed characteristically, after the iconoclastic controversy, by consistently portraying the mother of God and the child Jesus on her knees in the quarter-sphere of the niche canopy, in the sanctuary. The dogma of the first and second Coming of the Lord was expressed by presenting the 'Ετοιμαοία (preparation of the Throne) with the empty Throne of Judgment and the instruments of the Passion of the Saviour in the vault before the apse of the sanctuary. Finally, from the Macedonian and Comnenian period (tenth-twelfth century), the development of the monastic spirit, the cultivation in it of ecclesiastical literature, and the study of the apocryphal writings, gave the content to the contemporary iconography, which, especially during the period of the Palaeologoi (thirteenth-fifteenth century), became a narrative art. The iconographic compositions, from this period on, became richer and contained many persons; psalms and hymns (such as the Akathistos hymn) as well as many scenes from the Apocrypha, were depicted in the churches.

But let us see these things more specifically. As we said, the faith of the Church in the reality beyond this world, that is, in the truth of the spiritual world, from the beginning defined the essential character of the content of Eastern iconography. She is primarily interested in the beauty of this spiritual world and, with the means which she possesses, the Orthodox Church seeks to be the interpreter of that world. Her transcendental content is not the physically beautiful or the naturally good; and for this reason does not seek to project natural good and beauty (τό κατά φύσιν καλόν). Those, therefore, who see and judge Byzantine iconography with the conceptions of classical antiquity regarding the beautiful, will only confuse things. The purpose and the ideal of ancient Greek art was the presentation of the natural good and the beautiful by nature in that well known undivided unity of καλόσ καγαϑός (beauty and virtue). On the contrary, the purpose and the ideal of Eastern iconography is the expression of holiness, which, of course, is not made sensate by the physically beautiful, that is to say, it is not by necessity united to this. In antiquity the ideal was shown by the formation of things according to the laws of the naturally good.[2]

On the contrary, in Christian Eastern art the beautiful is determined not by the natural formation of the objects, but by its sublime content, that is, by its power of serving the ideals of the Faith. This is charac-

teristically confessed by St John Chrysostom: 'Οὕτω καί σκεῦος ἕκαστου λέγομεν καλόν καί ζῷου καί φυτόν οὐκ ἀπό τῆς διαπλάσεως, οὐδ'ἀπό τοῦ χρώματος, ἀλλ'ἀπό τῆς διακονίας'. (Thus, we say that each vessel, animal, and plant is good, not from its formation or from its colour, but from the service it renders.)³ Thus, what concerns the Church is the sublime purpose, the content of a superior spiritual quality, so that it regards as good any work whose formation, colour, and form in general can express this content. And the Eastern art did not copy nature nor seek the form or the colour as an end, but, taking such technical and artistic elements as were necessary for the believers to become familiar with its spirit, succeeded in rendering the more sublime meanings of Orthodoxy by means of an exceptional abstraction.

2. THE USE OF ICONS IN THE EASTERN LITURGY

The position of the mystery of Holy Eucharist in the Church is known from the beginning as it constituted the centre and the essence of the liturgy, which is but a representation of the mystery of the divine economy. The fundamental significance of the Holy Eucharist is not only unequivocally stated by the Fathers, but also manifested by Christian art in its most ancient monuments. Believers assemble in church primarily in order to experience the represented work of salvation in Christ and to participate at the Τράπεζαν Κυρίου (Lord's Table), to which the prayers, the hymns, and the sermon are directed. The liturgical act of the priest is a repetition of the one done in heaven by Christ, the great high-priest.

Generally from the era of the Macedonian and Comnenian emperors, the representation of the 'Θεία Λειτουργία' (divine liturgy) was reserved for the niche in the sanctuary depicting the great high-priest, Christ, below a ciborium (permanent canopy over the Holy Table)—rarely only once, but more commonly twice: transmitting on one side his body and on the other side his blood to the Apostles who in order or, as later, in groups approach with awe. But later still the divine liturgy was represented in this space in the form of its ideal performance in heaven, so that the sacred gifts are carried in litany by the angels wearing the vestments of deacons and are presented to the great high-priest, the Lord, as we have it in that excellent wall-painting in the Perivleptos church of Mystra, Greece (fourteenth century). Below the divine liturgy are depicted the 'σεβίζοντες' (the venerating ones), great hierarchs (especially from the Palaeologian period) with their liturgical scrolls (they are the editors of the divine liturgy). These personages are inseparably linked to the depicted mystery, a fact which was made more emphatic from the twelfth century onwards by the presentation of the sacrificed Lamb upon the paten, which later became the Μελισμός, that is, the painting of the Lord as a

child in this vessel (divided into pieces) and alluding to the sacrifice of the Lamb performed by the priest on the holy table.

The liturgical themes mentioned above determine especially the so-called liturgical inconographic cycle which, with the two other cycles (that is, the dogmatic and the cycle of feast days) dominate in the Eastern churches from the Byzantine period. Thus, the liturgical content is one of the principal characteristics of the essence of Eastern iconography.

When the Eastern Church calls us who 'τά χερουβίμ μυστικῶς είκονίζοντας' (mystically represent the cherubin) to 'πᾶσαν τήν βιωτικήν ἀποθώμεθα μέριμναν' (abandon every wordly concern) in order to receive the King of all who is invisibly escorted by angelic orders, Orthodox iconography comes to help more empirically in making this invitation as well as the whole purpose of the cherubic hymn more conscious. The ideal figures of the angels represented in the Eastern Churches, who approach with awe as they bear the gifts to the great hierarch Lord, and the Apostles, depicted in utter contrition and compunction, who come to receive communion from his immaculate hands, make perceptible the content of the hymn perceptible in the best manner and impose an understanding of it with their whole spiritual atmosphere. No other art, I think, ever succeeded in expressing what was expressed by the Orthodox art in Mystra (Greece). Here, in the famous wall-painting of the Perivleptos church, the fleshless figures of the angels in a magnificent rhythmic procession, bearing with fear and trembling the sacred gifts, and covering their eyes before the highest sacrifice, offer to the spectator, through the dematerialisation achieved, the impression of a vision from the other world and make incomparably perceptible the content of the liturgical hymn: 'Σιγησάτω πᾶσα σάρξ βροτεία καί στήτω μετά φόβου καί τρόμου καί μηδέν γήϊνον ἐν ἑαυτῇ λογιζέσθω . . .' (let every human being keep silence and stand with fear and trembling and think not of any earthly thing concerning himself). Truly, the technique and the style of the inspired iconographer succeeded in commenting excellently upon the magnificent hymn and in exalting the believers to its liturgical height.

What we have said should, I think, make apparent the significance of Orthodox iconography as a liturgical art, aiming to make understandable and conscious to the faithful the sublime content of the divine liturgy and especially the profounder liturgical act of the Holy Eucharist.

3. OTHER ELEMENTS OF EASTERN LITURGICAL ICONOGRAPHY

Eastern iconography is not simply a religious art, it is also theological. Its themes are not simply related to religious history, but are organised according to the high theology of the Orthodox Church. Roman Catholic

churches are usually decorated with pictures of the Passion of Christ, which are related to the familiar 'stations' of the cross of the Roman Church. Thus, the whole church is filled with the Passion, emphasised in a sided and exclusive way, while on the doors of the churches, the Church receives her faithful with the fearful scene of the second Coming. Eastern Churches, on the contrary, are filled with the twelve scenes of the great feasts from the whole life of Christ, the familiar 'Δωδεκάορτον' (Twelve Great Feasts). Thus, it is not only the Passion that is emphasised, but the whole life of the Lord, including the main events in his life from his birth until his ascension. In other words, the high theology of the divine economy is represented, which is certainly not confined to the Passion.

Whatever is taught by the divine liturgy, by the hymns of the Church and the words from the pulpit, is excellently commented upon by the silence of iconography. The cross of the vaults in particular, which covers the Eastern Church and which depicts within its four sections the whole life of the Saviour, gives the faithful standing below the impression that they are dominated by that sacred symbol *par excellence*, that they are under the protection of the Κυριακοῦ σημείου (the Lord's sign),[4] which contains and expresses all Christian teaching.[5] At the entrance of the church, at the βασίλειον πύλην ('royal gate') the faithful are received by Jesus, τήν θύραν (the door),[6] that is, by the Lord as teacher.[7] Later on, in the dome which rises at the centre of the church and at the point where the vaults cross, the triumphant figure of the Pantocreator, the Lord ἐξομολόγησιν καί μεγαλοπρέπειαν ἐνδεδυμένος (clothed in praise and magnificence), dominates over the entire area and is illuminated by the abundant radiant light which enters from the windows in the drum of the dome. As the Pantocreator is projected from the depths of the dome, the centre of the cross formed by the vaults appears to be hollowed and extended by him to the infinite, as if to denote that this central point of the cross is the triumph of the Resurrection, that its essence and depth is the victor over death, the infinite Lord, who dwells in heaven καί τά ἐπί γῆς ἐφορῶν (and supervises the things of earth), the immortal King of all to whom πᾶν γόνυ κάμψῃ οὐρανίων καί ἐπιείων καί καταχθονίων (every knee shall bend in heaven and on earth and below the earth).[8] Actually the dome became for the Easterns the symbol of heaven, while the Pantocreator, as already noted, was more specifically ὁ Πατήρ ἄμα καί ὁ Υἱός (The Father and the Son together), the expression of the doctrine of their consubstantiality. More generally speaking, we must see three other attributes which the Byzantine Pantocreator expresses. He is the Creator, the Saviour, and the Judge. This triple theological significance is successfully conceived and excellently rendered by Eastern iconography. Thus, the Byzantine Pantocreator possesses the royal magnificence of the Creator, the expression of the active goodness of the Saviour, and the

austerity of the impartial Judge. Even here the art, serving the ideals of the Church, created a work of great power which expresses a whole theology (Creation, Salvation, Judgment).

In the quarter-sphere of the niche in the sanctuary of Eastern Orthodox churches, the *theotokos* is usually depicted holding the child Jesus and escorted by two archangels. This quarter-sphere, with the rest of the niche, is the architectural section which unites the roof of the church with the floor; the upper (dome), symbolising the heavens where the Pantocreator is represented, is united with the lower, that is, the earth, the floor of the church, where the faithful are standing. Here, therefore, the *theotokos* stands between heaven and earth, as ἡ μεσιτεύ-σαοα τήν σωτηρίαν τοῦ γένους ἡμῶν (the intercessor of the salvation of our race) as ἡ κλῖμαξ ἡ ἐπουράνιος δι᾿ ἧς κατέβη ὁ Θεός (the heavenly ladder by which God descended), as ἡ τά ἄνω τοῖς κάτω συνάψασα (the one who united the upper with the lower) by means of the divine child in her arms. (Akathistos hymn.)

The representation of the Lord as teacher at the entrance of the church, the Pantocreator in the dome, and the *theotokos* in the niche of the sanctuary determine the so-called dogmatic cycle of iconography in the Eastern Orthodox Church.

4. RELATIONS BETWEEN EASTERN AND WESTERN ICONOGRAPHY

Totally characteristic of the content of eastern iconography is its depth. It is evident that a spiritual, a liturgical, and a theological art, as we have seen, should have sought to express depth and profundity in the representation of its themes.

What this means is that the iconography is directed not only to the sentiments, but also, and primarily, to the spirit. It does not seek to make a momentary and passing impression, but to create a permanent and continuous influence upon the soul by means of the understanding and practice of its content by the faithful. Indeed one Western icon of the Lord, for example, the so-called 'Blond Nazarene' (sic), with hair parted in the middle of the head and falling to the shoulders in uniform waves, with blue eyes, with the musing or melancholy countenance of nineteenth-century romanticism, and the whole naturalistic rendering of the figure, is perhaps directed, through the passion for beauty, to the emotion of certain people. But the lack of expressive power of such pictures does not move those who seek spiritual satisfaction, that is, those who seek under the expressive figures the shattering and profound idea of the icon, just as happens with the Byzantine icons of Christ in which the exuberance of the characteristics (such as the large eyes and the searching spirit) and the whole vigorous expression render, in the best possible

manner, the majestic and exalted spiritual mobility of the Lord's face.

What we are saying becomes clearer when we examine the icons of the Crucifixion in Western art in contrast to similar icons of Eastern iconography. Western art presents here the tragic drama of a man undergoing the ultimate agony of suffering. It is primarily directed to the emotions and seeks to move one by exalting human pain. And so Western artists compete to see whose work will be more dramatic. With the picture of the horror of a human corpse (cadaver) they seek the creation of 'sympathy' (*Einfühlung*)—in the artistic sense—in the spectator. Some examples of this, among many others, are the 'Crucifixion' of Cranach (1472-1553) in the gallery (Haus der Kunst) of Munich; the 'Crucifixion' of Fernandez (1566-1636) in the museum of Valladolid; the 'Crucifixion' of Goya (1746-1828) in Madrid (Prado), and especially the 'Crucifixion' of Grünewald (died 1530) in Isenheim, where the tragedy of the suffering Christ comes to a climax in the dying spasm displayed by the teeth projecting from the opened mouth and the foaming tongue.

By contrast to the above Crucifixions of Western art, in Orthodox Eastern art, the iconographers were concerned not only with the emotion but with the whole being of the believers. Thus, they created icons of the Crucifixion in which, in the face of the Lord, royal majesty (the majesty of controlled passion), calmness and serenity dominate and in this way express not so much the pain of martyrdom as the sublime theological significance of the completed sacrifice upon the Cross, which is condensed in Christ's world τετέλεσται . . . (It is finished, that is, his work is completed). Thus, while the Western painter, directing his work to the emotions, presented a human drama, the Orthodox iconographer, directing his work primarily to the spirit, expressed τήν ἐν σταυρῷ θείαν κένωσιν (the divine kenosis or emptying on the Cross) of the God-Man. Moreover, the Orthodox painter, believing with the Fathers and the hymn-writers of the Church that the flesh of the Lord did not suffer any decay whatsoever (ἡ γάρ σάρξ σου διαψθοράν οὐκ οἶδε δέσποτα 'for thy flesh, Lord, knew no decay'), represented the body of the Saviour without any change on account of death. The body of the Lord διά τόν ἐνοικήσαντα Λόγον ἄψθαρτον διέμεινε (remained incorruptible because of the indwelling Logos), according to St Athanasius the Great.[9] For this reason there are neither spasms of the mouth here nor effaced eyes; the colour of the body is not made greenish-yellow, nor distorted. The calm inclination of the head and the closed eyes are sufficient in great Eastern art.

Whatever is true regarding the difference between Western and Orthodox art in the presentations of the Crucifixion is also true in the representations of the Resurrection. In the Resurrection icon according to the impressive Latin type (created in the eleventh century in the West

and made known through Giotto) the Lord is usually represented holding a banner of victory as he is raised in the air as if by a vigorous jump from a sacrophagus tomb, whose slate covering is raised by an angel, obviously to permit him to exit, while the guards are shown fallen upon the ground. But according to the Eastern type, the Resurrection, from the ninth century on,[10] is shown primarily by Christ's descent into Hades. This iconographic type represents the Lord in Hades surrounded by a radiant glory;[11] he is trampling upon the demolished gates of hell and bears in his left hand the Cross of the Resurrection, while with his right hand he raises from a sarcophagus Adam, who represents the human race. Often, below the broken gates, one can see stretched out and bound in chains the personification of death as an old man, whom the Saviour θανάτῳ πατήσας (defeated by death), while he Himself was resurrected.

In contrast to the Latin type, the Byzantine Resurrection clearly expresses a more profound spiritual content. It renders incomparably the profound significance of the victorious Hymn of Easter:

Χριστός ἀνέση ἐκ νεκρῶν, θανάτῳ θάνατον πατήσας
καί τοῖς ἐν τοῖς μνήμασι ζωήν χαρισάμενος,

(Christ was risen from the dead; He defeated death by death, and to those in the tombs he gifted life.) This hymn declares that Christ, through his descent into Hades, defeated him who has the power of death, that is, the devil,[12] and by his Resurrection he liberated and resurrected the dead of old and redeemed the entire human race—living in darkness and death—whose symbol is the forefather Adam. The Eastern type, therefore, expresses, like the Resurrection of Jesus Christ, a universal redemption, that is, the work of salvation completed through the descent into Hades and the resurrection following the victory over Hades. Thus, the Resurrection is not merely, as in the Latin type (exit from the grave), a visible declaration of that very instant in time only, when the event of rising from the grave took place.

The Western type showing Christ jumping out of the grave was imposed upon Orthodox iconography during the Turkish domination (especially from the seventeenth century), through the influence of the West. It practically became the prevalent icon of the Resurrection, when in essence it is a type not only untraditional but orthodox. It shows the Saviour rising from the grave after the angel has moved the large rock for this purpose. But the removal of the rock ἀπό τῆς θύρας τοῦ μνημείου (from the entrance to the tomb), which is mentioned as a known fact by all the evangelists (Matt. 28:2; Mark 16:4; Luke 24:2; John 20:2), was certainly not done so that the Almighty Lord could emerge from the grave, but precisely so that the myrrh-bearers and the Apostles could see the empty tomb and verify the Resurrection. According to the Church

faith, the Lord was resurrected θεοπρεπεῖ δυνάμει καί ἐξουσίᾳ (by divine power and authority) while the tomb was still closed.[13] Moreover, οὐδὲ κεκλεισμένον ἦν τι τῷ ποιητῇ (there was not anything shut to the creator),[14] as we are further reminded characteristically by the hymn-writers:

Κύριε, ὥσπερ ἐξῆλθες ἐσφραγισμένου τοῦ τάφου,
οὕτως εἰσῆλθες καί τῶν θυρῶν κεκλεισμένων πρός
τούς μαθητάς σου,

(Lord, as thou camest out from the sealed tomb, so also didst thou enter while the doors were shut to thy disciples.)[15]

John Chrysostom also taught that after the Resurrection the angel came . . . for the women. In order that they may believe that he arose, they see the tomb empty of the body. For this reason, did he remove the rock.[16]

From all that we have said above, one should not think that Eastern iconography, during its long process, ignored natural reality, that is, the so-called realistic element. This element of realism, however, was not used as in the West, nor even as we perhaps understand it today (being taught so by the Renaissance), but rather for a definite purpose and only after it had been assimilated and subordinated to the whole vigorous spiritual power of Eastern art. Whereas in Western art the element of realism constituted an end in itself, that is, it was sought as an artistic ideal, in Orthodox art, on the contrary, it served another purpose, that is, the need to subordinate the material element to the spiritual, our lower nature to our higher. Moreover, the manifest subordination of the material to the spiritual in these icons also shows the beauty of high quality which the first element comes to possess from the second, that is the beauty which the material element ἐνδύεται (puts on) when it is dominated by the life-giving and life-transforming power of the spirit of 1Christ.[17] Christ, μορφωθείς τό καθ ἡμᾶς, ἐθέωσε τό πρόσλημμα (being formed in likeness to us, deified what he received).[18] And it is this deification, this theosis of human nature that is made perceptible by the art of Eastern icons.

Notes

1. P. G. Migne *Patriarch Germanos* 98, 384.
2. Plato *Politeia* 401, B.f.
3. P. G. Migne *Homily 4 on I Timothy* 11, 253.
4. According to Clement of Alexandria *Stromates*, 11 in P. G. Migne 8.

5. Ο λόγος τοῦ Σταυροῦ (the word of the Cross), according to St Paul, I Cor. 1:18.

6. John 10:9 (I am the door; if any man enters through me, he shall be saved).

7. Matt. 23:8.

8. Phil. 2:10.

9. P. G. Migne 25, 112.

10. See C. Kalokyris *Byzantine Wall-Paintings*, p. 75, note 9.

11. According to the Apocrypha p. 328, and to the bishop of Caron, Theodore Aboukaras (eighth century) P. G. Migne 97, 1496.

12. Heb. 2:14.

13. P. G. Migne *Cyril of Alexandria* 76, 1165.

14. P. G. Migne *Athanasius the Great* 25, 140.

15. *Pentecostarion* (Venice edition) p. 130.

16. P. G. Migne *Homily on Matthew* 58, 783.

17. In regard to the 'formation' of Christ in us, as St Paul writes 'until Christ be formed in you', see Gal. 4:19.

18. *Menaion* of December 24, p. 183.

Adrien Nocent

Gestures, Symbols and Words
in Present-day Western Liturgy

IF THERE is one thing that is clear about present-day European and American culture, it is that it has over the past few years become emphatically audio-visual. This new feeling for gesture and symbol links our culture up again with older civilisations and also with the civilisations of Asia and Africa. Films and television have accustomed us more and more to the presentation of images, and illustrated adventure and science-fiction stories are more and more widespread. This tendency could, of course, go too far and in that case would be the expression and signal of an alarming decline of culture. At the same time there is a real question as to whether an abstract intellectualism which makes no attempt to body itself forth in gestures is the best model of culture. Religious aspirations today also tend to want to express themselves by means of gestures. Charismatics show this in their meetings, for they instinctively make extensive use of bodily gestures, thereby exhibiting a marked contrast with the impassive serenity of those taking part in official liturgical assemblies. Karlheinz Stockhousen, the German musician, born in Cologne in 1928, in 1964 wrote *Inori* (Adoration) for soloist and orchestra. The piece is composed on the basis of a series of 13 pitches, 13 tempi, 13 intensities, to which correspond 13 gestures of prayer or *mudra*, borrowed from various traditions and performed by a dancer in the middle of a symphony orchestra of some 90 musicians. The dancer is referred to in German as 'Beter', a 'prayer', the one who prays. Gestures and music develop in perfect synchroncicity, so much so that the gestural part has its own score written for it. I can vouch personally for the fact that at every production of this work in the large towns I have been present at the audience took part in this danced prayer with great interior fervour. It

19

is impossible not to be aware of the contrast between the attitude evinced here and the distant and jaded behaviour of our congregations in many a place still.

This fact compels us to dwell on it now that fifteen years have elapsed since the renewal of the liturgy. And it would not be fair to criticise this recent reform without also criticising many of its applications with some severity. For it is strange that, in our audio-visual epoch where everybody talks about the need to adapt, we go to such lengths to refuse to allow even the most discreet symbolism and the most dignified gestures into our celebrations. This smacks of a fixed determination to prefer the ear to the eye. The fashion of the moment affects a sort of immobilism: the arms hang limply down the sides; any procession that might suggest a marching prayer on the way towards the altar, towards a meeting and dialogue with God, is suppressed as a piece of pompous formalism; a procession with the Book of the Gospels is proscribed as being a sort of relic of the middle ages—it is after all only a book like any other; the altar is primarily what it is rationally—a table; incense has been done away with since it belongs to another civilisation and has no symbolic relevance for us today; candles are only just tolerated, even though our present-day aesthetic sense of a banquet is incomplete without them.

1. KEEPING THE VISUAL AT A DISTANCE

This horror of gesture and symbol is pretty primitive and simplistic, but it seems to be rooted in a reaction against the clutter of accumulated riches piled pell-mell on top of each other and against the formalised and hollow performance of the liturgy that a misunderstanding of this clutter gave rise to. There is some excuse for repugnance to a liturgy based on 'court etiquette' and for the lack of enthusiasm for a romantic and mock-Cluniac reform. Such feelings are authentic enough and go with a certain ideal of poverty, but they do not justify certain colloquialisms that verge on the vulgar: the replacement of 'The Lord be with you' by 'Good morning, everybody', which is a paternalist adaptation if ever there was one, the work of clerics who are perpetual Peter Pans and children of the rich playing at having the common touch. And it is fair enough to be unhappy about a tendency to what has recently been called 'miserabilism'. This is certainly not what Vatican II wanted and these so-called applications cannot be laid at its door.

Is it not, however, the case that there has always been a suggestion of visual diffidence and aristocratic aloofness about our Roman liturgy? It, therefore, becomes important, if not indispensable, to try to analyse the attitude of the Roman liturgy down the ages. This is a delicate enterprise,

in which absolute and over-simplified affirmations have to be avoided. Space here does not permit anything more than suggestions for more serious work.

An examination of the liturgical documents of the first three centuries yields only indirect descriptions of the unfolding of the liturgy in Rome. Thus, the description which St Justin gives us in the year 150 contains no allusion to any gesture or symbolism of any kind: it confines itself to the essential and to the functional. It is true that he is writing to an outsider.[1] We have to wait for St Cyprian to have the mingling of wine and water, mentioned by St Justin, enriched with symbolic explanation.[2] We must, however, realise that this symbolism is theological in inspiration and is applied conventionally to the water and the wine, whereas the Eastern interpretation derives from the blood and water that flowed from the side of Christ. The same reservation applies to the Apostolic Tradition of Hippolytus of Rome 65 years later. We do, it is true, find here a blessing of the lamp which relies for its meaning on the symbolism of light.[3] When neophytes share in communion for the first time, they receive not only bread and wine but also water, milk and honey; these are symbols of the promised land—but also conventional specifics for newly-born babies.[4] Apart from the rite of total immersion, the laying-on of hands for confirmation,[5] the laying-on of hands over the offerings by the concelebrants during the Eucharistic prayer[6] and the laying of hands on bishops and priests during their ordination,[7] and the laying-on of hands on the deacon by the bishop,[8] there is no insistence on gesture symbols.

After the peace of Constantine, the liturgies diversified. Western liturgy became remarkable for the scope of its creativity, but this was limited almost exclusively to the euchology, for its gestures and symbols remained very sober. Even when solemnities came to be created on the model of the development of the liturgy for Christmas in the context of the victory of the sun over the clouds, the liturgy did not develop a corresponding symbolism. The euchology and Roman canon might well contain such Constantinian and imperial expressions as *Honor, secundus meritus*; the Roman canon might well seem influenced by the central preoccupation of the pagan cult, namely, the offering, but the symbolism still did not come into the liturgy of Rome along with the terminology and literary forms. How is one to explain this apparently deliberate rejection of symbolism and gesture? Is it because of a conscious opposition to the practice of contemporary pagan religions? Or is it on account of the insistence on that spirituality of worship which distinguishes the Christian cult? Or is it a matter of prudence and the desire to avoid all confusion? It is St Ambrose of all people who seems to testify to this perplexing rejection of symbolism on Rome's part. The context is that of the washing of feet, which in Milan takes place as the neophytes emerge from the

baptismal font. This is the way they are welcomed by the community. St Ambrose seems to feel the need to justify himself, and he writes: 'I desire to follow the Roman Church in every respect; at the same time we too have minds. That is why we preserve such customs as are observed elsewhere for better reasons and so have better reasons for doing so.'[9] In the whole of this passage of his treatise St Ambrose is trying to work out for himself why the Church of Rome did not preserve this symbolic gesture and he justifies himself by writing: 'It is the apostle Peter himself whom we are following, it is his fervour which we are embracing. What does the Church of Rome say to that? For it is indeed the apostle Peter himself who suggests this course of action to us, and he was bishop of the Church of Rome. It is Peter himself when he says: "Lord, not my feet only but also my hands and my head" (John 13:9).' So St Ambrose registers a lack of enthusiasm for symbolic gestures on the part of the Church of Rome, even when they are ones that the Lord himself performed and which he regarded as important. She seemed to confine herself to essential rites and sacramental signs. Not that the ancient Church as a whole was unacquainted with such things. Etheria, in the account of her pilgrimage to Palestine, recorded the expressive rites of Holy Week in Jerusalem,[10] and especially the ceremony of light, symbol of the resurrection. The Church in Rome enriched its celebrations only later, and then only by copying such symbolic presentations rather sparingly, as, for example, by importing the adoration of the Cross. Later still it accepted the customs of the Frankish Church.[11] Even so, these importations, copied from other liturgies, were not always well received, and St Jerome wrote a harsh letter accusing the *Exsultet* of frivolity.[12] This is why the papal liturgy knew this song rather late. When Lent began to develop through the rite of the catechumenate, the Church of Rome accepted the essential rites, like those of the laying-on of hands, the Ephpheta, the handing over of the symbol of the faith and of the Our Father, and of the gospels.[13] But Rome had no equivalent to the very expressive rite of renunciation known in the East: the candidate, bare-footed, and facing the West, the symbol of darkness, spits in this direction, and then turns towards the East, whence the light of Christ dawns from on high. We should also bear in mind that the most ancient basilicas in Rome were not oriented and that it was only later that Rome began to take note of orientation.

2. THE INFLUENCE OF OTHER LITURGIES

We should, however, note that Rome may have had little taste for symbolism but that it did not close itself to the influences of other liturgies, or even, surprisingly enough, to pagan symbolism, provided

only that it did not lend itself to any confusion. This is why it provided for a celebration of the Eucharist that included the blessing of the wife,[14] and yet was quite content with the ordinary family ritual of marriage, and this right to the end of the eleventh century.[15]

Ordo Romanus I of the mass could have introduced some gestures into its description of the papal celebration, for instance, in connection with the use of Africa according to which the faithful brought their gifts to the altar. The ritual is, on the contrary, reduced to the minimum in that the pope and his assistants take the gifts themselves without a procession of the gifts.[16] It is only the prayer *super oblata* that gives the offertory its theological significance. The description of several other rites in this *Ordo*—such as that of the procession from the Lateran to the basilica of Santa Maria Maggiore by way of the Via Merulana[17]—might suggest a certain triumphalism on the part of the bishop of Rome. We must, however, be accurate and record a rite that is purely Roman in origin and is profoundly theological in function: the rite of *fermentum*. According to this rite, when certain priests have been deputed by the pope to celebrate the Eucharist for faithful who live too far away from where the pope is celebrating, then at the moment of the breaking of the bread, a fraction of the consecrated bread is sent to them so that they can place it in their chalice, as a sign of their unity with the local bishop, thus emphasising just that aspect of the theology of the Eucharist which was so dear to St Ignatius of Antioch.[18]

This ritual austerity was not accepted everywhere and in the ninth century France witnessed the birth of such eccentric symbolical explanations of the Eucharistic celebration as those of Amalarius of Metz.[19] This symbolism originated, of course, in a lopsided theology of the mass in so far as this was seen as a divine representation of Calvary, symbols of which were, therefore, to be found in the most minute gesture of the celebrant. And we know how Florus of Lyons combatted this luxuriant symbolism that verged on heresy.[20]

In Germany during the tenth century the monks of St Alban of Mainz were by dint of great ingenuity able to make even the Roman euchology more visual.[21] The Roman-German pontifical, therefore, marks a very important phase in the history of the development of the Roman liturgy, for this absorbed many usages of the German pontifical into its own pontifical in the twelfth century, thereby manifesting its desire to welcome certain forms of symbolism which it did not have the spark of genius to create for itself.[22] This did not, however, prevent Gregory VII from protesting that the Romano-Germanic pontifical spelled a destruction of the Roman liturgy.[23]

The Roman liturgy nevertheless continued to adopt symbolism which it found elsewhere. At the end of the thirteenth century it allowed itself to

C

be influenced by the pontifical of William Durandus of Mende and virtually made that its own, right down to the recent reform of Vatican II. Worthy of special note is the rite of reconciliation, which consists in a dramatisation of the rite of penance for the morning of Maundy Thursday. The Bishop of Mende had introduced into it some usages and antiphons that were theologically very rich.[24]

It is enough to open the collection of manuscripts copied by Edmond Martène in his *De Antiquis Ecclesiae Ritibus*[25] to see how much people outside Rome felt the need of symbolism that was only too often absent from the Roman liturgy.

3. INTELLECTUAL ARISTOCRACY?

This survey is unduly summary for its subject-matter but also unduly long for this article, and yet it can allow us to draw some very firm conclusions about Rome's attitude towards symbolism. This amounts not to repugnance—this would just not square with the way Rome often welcomed symbolism—but to reticence and even a notable indifference towards symbolism, or, more exactly, to an astonishing absence of possible creativity in this regard. Roman liturgy is undoubtedly very cerebral, very undemotic, and it is hardly surprising that what we nowadays call 'popular religiosity' should have been an instinctive reaction on the part of the Christian people who could not be satisified by celebrations that were first and foremost euchological.

It is here that we come to the heart of our subject: Could it not be that the recent reform of the liturgy, often inspired as it was by a return to the sobriety of the past and of antiquity, has not gone too far towards that intellectual aristocracy of spirit which characterises the genius of ancient Rome? A perusal of the rituals of the different sacraments, of the rite of the Eucharist, of the Christian year, discloses a patent desire for sobriety and for an often radical suppression of anything that is not functional. A look at the rite of Holy Week alone, compared with what it was before, shows this. The renewal of the liturgy certainly ensured the authenticity of the rite of light and of the Vigil by restoring it to the night of Easter in accordance with the historic data of the gospels. At the same time, it is clear that anything a little out of the ordinary in, say, the different offices of saints' days, or certain ommissions from the mass like the offertory and the Agnus Dei on Holy Saturday, was brought into line with ordinary practices at Matins, Lauds, etc.

It is this rather intellectual return to the past of the liturgy that could be the reason for a certain visual poverty which does not correspond to our needs today. We have already seen how very intellectual the liturgy was in ancient Rome. This is not easy to analyse even when we see it in its

context. The very fact that the liturgy of Rome had this predominantly euchological and relatively unvisual character distanced if from its own surrounding culture, and the need for more visual celebration was being felt even then, though we need not attribute to the Romans of old the same need to be demonstrative that people feel today. Nevertheless the very text of certain liturgical celebrations betrays the attraction which some Christians and even some priests felt for the more spectacular and luxurious pagan celebrations such as the Lupercalia.[26] It is clear that the Roman liturgy did not satisfy the instinctive needs of many Christians and many fairly soon had recourse to supplementary devotions. This tendency became more and more pronounced as the centuries elapsed and especially when biblical culture began to disintegrate. This is the way in which a serious gap opened up between the official worship and celebrations that were more or less spontaneous or else allowed and even encouraged by the authorities, though they were parallel to the liturgy and even replaced it, so that devotion became more important than the essential rite. By the same token, there is cause to fear that a renewal which concentrates too much on the ear and leaves so little scope for the eye will open the door to similar parallel developments. The attempts made by the reform of Vatican II to restore the Word of God to the celebration will no doubt bear fruit, but will this restoration suffice to appease the visual needs we feel today?

4. THE POSSIBILITY OF THE VISUAL

It is here that we must pose some delicate but unavoidable questions. The renewal of the liturgy has proceeded by going back for the most part to antiquity in order to discover the essence of a celebration underneath successive symbolic layers coming from more or less everywhere. This has been a very useful service, and it would be unfair to deny this. But could we not say that precisely by giving us a framework cleaned and cleared of all extraneous matter the renewal itself offered us the possibility of introducing the visual wherever local and contemporary needs warranted it? This seems to emerge—tentatively, no doubt, but definitely—from several parts of the new rituals wherever conferences of bishops are given the discretion to allow such and such a gesture into the celebration. This applies to the case, for instance, of the rite of Christian initiation of adults and of the baptism of children. We must, however, admit that scope for such discretion to adapt remains very limited. On the other hand, it would be dangerous just to open all doors, for we cannot think of reintroducing the visual into our predominantly auditory liturgy without first undertaking objective research. And we can proceed with this only by stages.

The first stage in any such programme of research would consist in an

objective study of the symbolism and gesture which our present liturgy already offers us. As I have already indicated at the beginning of this article, some people have jumped to the conclusion that what they happened to consider formal and unadapted is in fact so, whereas it may not be seen by the faithful in so inhibited a way. Only to often clericalism still prevails here in the form of projecting the clergy's own sentiments onto the faithful.

The second stage would consist in attempting to ascertain those moments of a celebration which demand symbolism and gestures. This clearly requires more study, because symbolism and gesture should not be introduced artificially. The necessity for technical study does not justify an artificial introduction. We must therefore study history and we must do so by studying it with the precision tools of anthropology.

The third stage is the most important one: What was done yesterday does not rigidly determine what we have to do today. It would, therefore, be a question of seeing how the symbols and gestures of the past in all the variety of their local adaptations, meet our needs today. At the same time, the replies to such interrogations of the past, whether affirmative or negative, cannot be the last word. For the fact that any particular symbol or gesture is esoteric cannot of itself close the question. The liturgy must indeed be incarnated because of the incarnation of Christ, and yet the adaptation involved must also take account of the fact that Christ became incarnate in a given historical culture, and one must therefore respect the visual dimension of this incarnation of Christ. There may, therefore, be symbols and gestures which are not immediately intelligible and which require catechesis. This is already the case for the inspired word, which is integrated into a culture that we must respect. At the same time, we have to study the possibility of introducing new gestures and new symbols. The work involved here is fraught with hazard, however necessary it is, and it supposes intelligent prudence and a clear awareness that the results of an anthropological inquiry cannot state the last word.

If the liturgy is life, it is hardly surprising that it should always be growing.

Translated by Iain McGonagle

Notes

1. See especially the description of the mass, chapters 65-67.
2. Cyprian *Epistola 63 ad Caecilium* ed. Bayard, Collection Budé (1925) II p. 208 (P.L. 4, 384).

3. Hippolytus of Rome *La Tradition apostolique* ed. B. Botte (Coll. Quellen und Forschungen, Münster, Westphalia) n. 25 p. 64.

4. *Ibid*. n. 21 p. 56.

5. *Ibid*. n. 21 pp. 48, 50, 52.

6. *Ibid*. n. 4 p. 10.

7. *Ibid*. n. 2 pp. 4-6; 7 p. 20.

8. *Ibid*. n. 8 p. 22.

9. *De Sacramentis. De Mysteriis* ed. B. Botte (Sources Chrétiennes 25 bis 1959) 3, 5 p. 95.

10. Etheria *Journal de voyage* ed. H. Pétré (Sources Chrétiennes 21) pp. 218-244.

11. For Palm Sunday, for example, see H. Graf *Palmenweihe und Palmenprozession in der lateinischen Liturgie* (Stelyer 1959).

12. Jérôme 'Lettre à Praesidius' ed. G. Morin *Bulletin de l'ancienne litterature et archéologie chrétienne 3* (1913) pp. 52-60.

13. *Sacrementaire Gélasien* ed. L. C. Mohlberg (Coll. Rerum Eccles. Documenta, Rome 1966) nn. 283-328.

14. *Sacrementaire de Vérone* ed. L. C. Mohlberg (Coll. Rerum Eccles. Documenta, Rome 1966) nn. 1105-1110; *Sacrementaire Gélasien* nn. 1443-1455.

15. K. Ritzer *Formen, Riten und religiöses Brauchtum der Eheschliessung* (Münster 1962).

16. 'Ordo Romanus I' ed. M. Andrieu in *Les Ordines Romani du haut moyen âge* (Coll. Spicilegium Sacrum Lovaniense, Louvain 1960) 2, p. 91 nn. 69-78.

17. *Ibid*. pp. 69-76 nn. 7-28.

18. *Ibid*. Le *fermentum* p. 61; *Ordo* II n. 6; *Ordo* IV n. 106 and p. 169.

19. Amalarius of Metz *Liber Officialis* (P. L. 105, 985-1242); *Amalari Episcopi Opera Liturgica Omnia* (Città del Vaticano 1948-1950), Coll. Studi e Testi 138-140.

20. A. Franz *Die Messe im deutschen Mittelalter* (Freiburg 1902) pp. 359, 394.

21. *Le Pontifical romano-germanique du Xième siècle* ed. C. Vogel and R. Elze (Città del Vaticano 1963) 1 and 2, (1972) 3, Coll. Studi e Testi 226, 227, 269.

22. *Le Pontifical romain du XII siècle* ed M. Andrieu in *Le Pontifical romain au moyen âge* (Città del Vaticano 1938) Coll. Studi e Testi 86.

23. M. Andrieu *Les Ordines Romani du haut moyen âge,* cited in note 16, 1 p. 519, 1.

24. 'Le Pontifical de Guillaume Durand' ed. M. Andrieu in *Le Pontifical romain au moyen âge* (Città del Vaticano 1940) 3, Coll. Studi e Testi 88.

25. Reference may be made much more reliably to this book since the publication by A. G. Martimort of *La Documentation liturgique de Dom Edmond Martène* (Città del Vaticano 1978) Coll. Studi e Testi 279.

26. This is proved by the protests introduced by Pope Gelasius into the very formularies of the mass. See *Gelase Ier. Lettre contre les Lupercales et 18 messes du sacrementaire léonien* ed. G. Pomarès (Sources Chrétiennes 65, 1959).

Aidan J. Kavanagh

The Politics of Symbol and
Art in Liturgical Expression

WHEN ONE discusses symbolic and artistic expression in liturgical worship, there is an aspect which often is never mentioned. It is the political aspect, and it touches all phases of the issue.

1. THE NOTION OF 'POLITICS' EMPLOYED

The politics one refers to is not primarily that assumed by modern popular consciousness. It has little directly to do with concepts of the state, the governing process, or methods of liberation from oppression. Politics as it will be used here means simply the structure and quality of the relationships between members of a social group, including the elusive ways in which these relationships are sustained both by governance and by social contract, usually unwritten. Politics in this sense, it will be remembered, is a most liberal art, the breeding ground of symbol and the other arts.

Symbol and art are difficult enough to speak about, but their political roots are even more difficult to articulate. Perhaps for this reason most normal social groups seem less to analyse their symbols, art, and politics than to practise them. Learned papers on Zulu art and symbolism astonish no one more than the Zulus. The point being that living at normal depth within a society's functioning patterns of symbol and art seems to be an impediment to having a clear analytical grasp of their scope and function. Anthropologists therefore tend to study almost any culture so long as it is not their own. The methodology of critical analysis requires an objectivity that can be had only at a certain distance from the object studied, a distance that comes either from being an 'outsider' or from a

28

crisis of alienating proportions within. This last instance suggests why those in political or cultural power usually find themselves at a disadvantage in defending a shifting *status quo* against revolutionaries. The latter, by definition to some extent alienated from the given order of things, specialise in analytical critique at the expense of the former, who often have no response except flight or coercive force. The successful revolutionary invariably must then overhaul not only the politics but also the symbolic and artistic patterns of the society. Symbol and art may cause political evolution, but political revolution makes drastic shifts in symbol and art a necessity, as the recent histories of Russia, China, and more lately Iran illustrate.

So too the recent history of Roman Catholicism, especially since the summoning of the Second Vatican Council in 1959. Whatever else the Council did, it sanctioned a political shift in the structure and quality of the relationships between Roman Catholics at every level, including the elusive ways in which these relationships are sustained both by governance and by unwritten social contract. The political breeding ground of symbol and the other arts therefore changed to a degree that is still not possible to fathom, much less to be clear about, since the results of the change have by no means yet run their course, pulling many of the other Western churches along with them. It cannot be forgotten that the perhaps more modest results of the political shift sanctioned by the Council of Trent took almost four centuries to run their's.

2. THE POLITICAL SHIFT OF THE VATICAN COUNCIL

While any analysis of the political shift sanctioned by the Second Vatican Council must be highly tentative due to one's close proximity to it in time, it may be possible to point out some results it seems to be having upon the worshipping assembly's symbols and art, especially as these regroup themselves within the reformed liturgy.

To be brief about it, the reformed liturgy simply assumes a participatory politics that is less aristocratic and élitist than that assumed by the liturgical settlement sanctioned by the Council of Trent. While one might often point out that the Roman liturgy originated in such a participatory politics, the roots of which reached back even to a supper in an upper room, and while one might also point out that even the Tridentine liturgy *could* be participated in actively by all (as in the *missa recitata*, the 'dialogue mass', or the German *Gebetsingmesse*), nonetheless its language and art forms made this difficult if not impossible to accomplish. Many parishes with few resources found the effort needed to teach congregations Latin and Gregorian chant greater than the positive pas-

toral results that were expected. The resulting silent masses led to the near displacement of the liturgy by a surrogate form of endeavour called sacramental confection. Generations of seminarians were taught not how to celebrate the Roman liturgy but how to confect a sacrament according to officially approved Roman texts. Thus the active cooperation of a congregation and other ministers was recommended but deemed unnecessary on the whole.

This is not the place to detail the results of centring so much on the priest's act of sacramental confection—how it largely rendered private not just the Eucharist but the whole of the Church's liturgical system, how it impacted sacramental theology, and how it made bringing *liturgical* data to bear on a whole range of theological and pastoral issues almost impossible. The liturgy sank nearly to the level of adiaphora where, paradoxically, many sixteenth-century Protestant reformers had said it ought to be.

It can be maintained that such a situation as this provides the only context which explains satisfactorily why by the mid-nineteenth century a liturgical ferment began to stir in Roman Catholicism and was addressed with increasing frequency by popes beginning with Leo XIII in 1902. It is estimated, indeed, that the next seventy-five years witnessed the issuance of at least 300 documents of all kinds on liturgy by the Roman See.[1] So formidable a body of official literature is not produced except in response to formidable problems: both are essential background for grasping the seismic political shift that was sanctioned by the Second Vatican Council. Against the conventional shrinkage of liturgy to sacramental confection centring on the priest's private low mass, the *Constitution of the Sacred Liturgy* reasserted the traditional norm of Eucharistic celebration. It is to be that of the bishop presiding within an event that concretely expresses the full involvement of the whole local church—people, presbyters, deacons, and other assistants.[2] The norm requires, even when it must be departed from for serious reason, that the Church be manifested in all its variety and diversity in all its sacramental deeds; but especially in the Eucharist, which is the mode in which the Church itself most regularly assembles.[3]

The contrast between this restored standard of Eucharistic celebration and the previously prevailing one of the individual priest's private low mass illustrates the dimension of the political shift sanctioned by the Second Vatican Council. Yet the participatory politics of the Council's standard for the Eucharist was hardly new in Roman tradition. Such a politics is evident in the earliest sources of Christian liturgical usage—sources which were being rediscovered, edited, and published during the scholarly phase of the liturgical movement from the sixteenth through the nineteenth centuries—sources which were the support of those con-

servative innovators of the pastoral phase of the same movement from Guéranger and Moehler in the nineteenth century to Beauduin, Pius X, and Pius XII in the twentieth. The shift was thus anything but sudden: it was the result of a long-term political process of recovery set in motion by many factors including the collapse of medieval Catholicism, the reforms of Trent, scholarly historiography, and three centuries of social revolution in the West.

As is the case with any long-term social process, some structures and attitudes changed more slowly than others. In the West, for example, changes in liturgical practice, which began to come with increasing frequency only after Pius X altered communion discipline in 1905 and 1910, were relatively easy to set in motion due to the liturgy's having been made a latter of law administered exclusively by the Holy See. A politics of aristocratic authoritarianism thus immeasurably aided Catholic liturgical reform during the half-century prior to 1959. Yet the substance of the reform, once it was sanctioned and given strategic scope for the Church universal by the Second Vatican Council, went far beyond mere rubrical changes, discreet alterations of policy, or indults given in specific instances. The liturgy was given back into the hands of the faithful, that fundamental *ordo* of the baptised which all orders of ministry are ordained to serve.

There can be no doubt that any future history of Roman Catholic worship in the several decades since the Second Vatican Council will have to discuss at length how both faithful and clergy found ways in which to cope with a situation of restored liturgical normality after so long a period of liturgical abnormality. Such a future history will perhaps be able to see more clearly than the present generation can do that the main liturgical problems after the Council were less those of rubrical changes and the proliferation of trial texts than those of working out ways of maintaining liturgical discipline and governance within a restored participatory politics. In this, both clergy and faithful are having to rediscover that tradition rather than canon law is the force that gives thrust to liturgical development. This is so because tradition is that continuity which gives shape to participatory politics, a continuity having nothing to do with the dead hand of the past but everything to do with the community's awareness of its present. Such an awareness, if it is to be both accurate and to some future purpose, can never be amnesiac about the past. For the past is where presents are made, and presents are the future's beginning.

Written histories of the Church covering the past four centuries unfortunately do not often give much help concerning how all this might be done. Such histories usually focus on the politics of the Church, especially at worship, as being aristocratic and élitist. So long as this politics survived, its liturgical manifestations still had access to the symbolic and

artistic forms which that politics had produced—such as monastic chants of great monophonic beauty, composed masses and motets, towering plastic and architectural artifacts, and a body of literature as good in some ways as any which had preceded it. These monuments, which involved a certain style in symbol and art and which founded a whole piety, were largely produced by virtuosity made possible by benefaction intended to benefit the masses, who were expected to be reverential toward benefactor, virtuoso, and product together.

3. RESULTS OF THIS SHIFT

Three centuries of political upheavals both in Europe and the new world changed all this or at least rendered its underlying politics moribund, and the change finally penetrated the liturgy significantly in the 1960's. Liturgical scholars were no more prepared for the results, it seems, than anyone else. Many were alarmed when participation in the liturgy degenerated into a sort of egalitarian *camaraderie* whose novelty produced an elation that dwindled as the presumably solid artifacts of the aristocratic past either collapsed or sank beneath a whole new political climate in the worshipping assembly. More often than not, given a choice between a poorly performed 'folk mass' and a splendid high mass set to Gregorian chants and Palestrina, all the young and most of the old chose the first. The liturgy increasingly became talky, didactic, and prone to ideological manipulation. That the Eucharist, the sacrament of the Church's faith-communion in Christ, was perhaps more alien in an act of anti-war protest on the steps of the Pentagon in Washington than was a solemn concelebrated exorcism seems to have crossed the mind of no one except Mr Norman Mailer, the American author, who composed a splendid exorcism precisely for such use.

There is some initial evidence that the rush into liturgical egalitarianism has begun to moderate as the novelty of the shift into a more participatory politics as manifested in the reformed rites has begun to wane. One hopes that some hard lessons about aggressive egalitarianism have begun to be learned—that in liturgy as in politics, science, education, and family affairs it produces euphoric mediocrity at best and a hopeless tangling and flattening of due process at worst; that participatory politics and egalitarianism are by no means synonymous; that an élitism of career clergy and ecclesiastical princes is not significantly different from an élitism of experts, committees, and guidelines.

Concerning this last lesson, one's hope remains modest. For the reaction that seems to be gathering from our having begun to learn the first two lessons about egalitarianism (a reaction beginning to be called a 'new

conservatism' in American seminaries) gives evidence of being tinged with an unhealthy sort of nostalgia for a liturgically aristocratic past and, paradoxically, with an even less healthy presumption that modern secular bureacracy can provide the categories (high degrees of professional specialisation and organisation) that will allow such an aristocracy to work. Bluntly stated, ordination is becoming 'academicalised' to the point that obtaining an academic certificate of specialised competency overshadows the sacrament of holy orders. One obtains one's academic certificate and then searches for a pastoral situation in which one can exercise one's specialty. The specialisation of ministry, not in itself a bad thing on the level of the diaconate and the lesser orders, becomes a mixed blessing when it is inserted into the presbyterate and episcopacy. It narrows these two orders to 'job descriptions' of an implicitly bureaucratic sort to the detriment of their primary sacramental, presidential, and ascetical nature. Furthermore, given the tendency of the presbyterate to become the paradigm for all ministry in the Western churches at least for the last thousand years, allocating a large repertoire of specialised competencies to it is a sure way to recreate it as a modern aristocracy of 'first-class citizens' by certification in the Church.

But the matter is complicated further. What such a recreation produces is a minister whose ability to preside comfortably within a tradition of worship as distinctive and rich as the Roman is significantly reduced. Such a one's presidency is often idiosyncratic in the extreme, due perhaps to its being a personally therapeutic event of secondary importance to one's real professional work, which lies elsewhere. Liturgical presidency thus shrinks to a matter of personal need for the minister. The assembly and its worship end by serving the minister, rather than he them.

That participatory politics is not mere egalitarianism seems to be increasingly clear to many. That it cannot be allowed to be swamped by therapeutic élitism for weary ministers will, one hopes, become equally clear. Participatory politics as the recent Council and tradition understand it does not arise or function in the Church along exclusively secular lines. The worshipping assembly does not recognise the origin of its internal political 'power' as lying with competencies, committees, or ideologies, but with Jesus Christ present and active in the Church, both universal and local. As an enacted icon of this, the liturgy draws its power not from the committee which controls the worship programme of the parish, or from the scrupulous idelogical fairness with which special ministers are approved, or from the pastor's tastes, but from the active presence by faith, word, and sacrament of Jesus Christ in the Church's midst. One does not become a Christian by being elected pope, ordained a presbyter, or appointed to a parish liturgical committee, but by being plunged into Christ's own death through baptism. One does not remain a

Christian by obtaining an academic degree, joining a charismatic prayer group, or by voting for or against this or that, but by participation in Christ's body broken and his blood poured out Sunday by Sunday. One is not initiated into Christian communion on the basis of what one thinks of liberation theology, the ordination of male or female, or the 'democratisation' of the Church, but in response to one's stated faith in Father, Son, and Holy Spirit.

4. THE POWER BY WHICH THE CHURCH LIVES

If to speak of politics necessitates speaking of power, then the foregoing truisms seem to need restatement over and over again, as John Paul II did for the whole Church in his remarks to the Peubla conference of Latin American bishops in 1979. And perhaps the main fact made clear by this Slavic pope's journey to Poland later that same year, a fact deserving much consideration by the churches west of the Iron Curtain, is the sheer power of Christ's active presence especially in faithful churches where parish schools are outlawed, clerical vocations restricted, and hierarchies shackled. One has the impression that *because* of state hostility and its repressive policies the Polish church has in its own way generated a participatory politics after the mind of tradition and the Council that is unsurpassed among churches further West and unequalled except in certain churches in Africa. Against the powerfully renewing lives of these churches—lives forced through suffering back to basics— the lives of 'first world' churches appear largely to be over-financed, over-educated, and over-organised, gradually losing their self-confidence in direct ratio to the secular state's withdrawal of its approval and support.

The Catholic Church in the United States, for example, gives evidence of becoming increasingly enervated by polarising debates on a series of issues that are essentially introverted and self-indulgent. The issues are supported by special interest groups who have learned from the civil rights and anti-war movements of the 1960's how to turn society's corporate life-thrust (for better or worse) to their own purposes—frustrating development, dispensing political power, and rendering a consensus by the slimmest majority of only one or two statistical points the best that can be hoped for. With this, a sense of communal identity begins to ebb, frustration rises, bishops become little more than mediators in endless disputes, and the liturgy becomes a battleground where vested interests collide not over accidentals but over essentials—such as whether the Eucharist even *can* be celebrated until all justice is attained, all the

hungry fed, women ordained presbyters, all oppressive régimes toppled, and until the Church has taken the 'correct' stand on every issue sensationalised by the mass media.

The faithful community, afloat upon a sea of polarised permissiveness, is numbed by aggressive arguments that do not relativise its values so much as they atomise them into an incomprehensible state. Yet these are the values whose mutual communion produces art and symbol, major components in that complex symphony of artfully enacted meaning which the liturgy is. The liturgy celebrates nothing if it is not an agreed upon commonwealth of lived presumptions in faith: when this either collapses or becomes so intricate as to be arcane, the liturgy loses its ability to lift its participants to a level where the whole can be perceived simply and participated in directly by all. Then the liturgy dissolves into an educational set-piece or an arena for conflict, and the faithful go elsewhere for their 'images of survival'. For survival is what the liturgy is ultimately about—survival in Christ through his own passage from death to life in his Father. Christ is the fundamental image of survival, an image that causes what it signifies because it is its own content.

This is not only the definition of sacramental liturgy. It is at the same time the source from which all great Christian art has arisen and the foundation in power which holds the Church together. It is both the precondition and outcome of all Christian life. And its maintenance is not produced merely from a tentative encounter with Christ, but from that sustained mutuality of presences between Christ and his faithful ones tradition calls communion—a state of existence which Paul likened to the wedded union between man and woman, and which Aquinas termed the *res* of the Eucharist, the *unitas mystici corporis Christi*, the Church. Taken whole, it is not easy to be too firm about this fundamental principle of Catholic orthodoxy. To be mediocre about it is to trivialise it and thus to lapse gently into apostasy from it on many levels at once.

The political is one such level. Indeed, the theandric nature of the incarnation of Jesus Christ, together with the maintenance of that incarnate presence by faith, grace, and sacrament corporately in the Church, assured that politics would be a central issue in orthodox Christianity from the beginning.[4]

Church governance and the sustained relationship of the churches of God was anything but a tertiary consideration, as the Acts of the Apostles, the Didache, and the letters of Ignatius and Clement make clear even in the most primitive strata of Christian documents. Yet these sources and others like them never make the mistake of assuming that Church governance takes its beginning anywhere but from within. No other factor can account for the relative ease and self-confidence with which the Church of the first thousand years absorbed cultures, renewed them, and

then both authored new ones and maintained its right to stand in judgment of them.

5. THE DANGERS EXPERIENCED

Historically, two dangers have arisen in this regard. The first is the danger of becoming rigoristic about this, with the consequence that the Church turns away from all possibility of political entanglement with the world of human affairs, introverting itself and becoming exclusivist. Certain forms of Christian spiritualism have always had an affinity for this sort of theological anarchism which often has ended in a degree of monophysitic emphasis on the divinity of Christ and the divine aspects of the Church or Christian experience to the detriment of the human in both. Orthodox tradition has been quick to diagnose such a shift, despite the benign appearance of its piety or the warmth of its devotionalism, as being a fundamental assault upon both the relation of creation to Creator and the theandric nature of the incarnation, seeing it thus as heterodox in nature and sectarian in effect. The tradition has reacted in a similar manner towards the opposite alternative, that of emphasising the human nature of Christ and the human aspects of the Church or Christian experience, as one finds in forms of arianism or pelagianism. While it is a risky generalisation, one might characterise the monophysitic temptation as typical of the pious Christian 'conservative' (Archbishop Lefèbvre and some modern charismatics), and the arian-pelagian temptation as typical of the socially radicalised Christian 'liberal' (as in the reductionisms of some liberation theologians). In the first, one detects a flight from politics: in the second, political excess. At their extremes, each is an assault on the gospel and all that flows from it.

A second danger is by far the more difficult to diagnose and counteract. For it issues not from clear and internally logical, if mistaken, apprehensions about Christ, the world, and the Church, but from a slothful and unresourceful muddling of sacred and secular, of gospel and world, of Church and state. On the American scene in particular, the religious roots of which derive mainly from influxes of Puritan, Catholic, and Jewish immigration from the seventeenth to the early twentieth century, one finds that perhaps the new thing produced by such commingling of traditions is not a renascence of Judaeo-Christianity but a religious syncretion of a peculiarly nineteenth century American sort seen in the Church of the Latter Day Saints (Mormons). In this group the American virtues of independent self-reliance, family-centredness, hard work, and stable middle-class values, together with the special American vices of a certain proness to religious humbug, a gentle xenophobia, and a taste for glitter and random display, are combined in a corporate empire of massive wealth and political influence that radiates out from Utah over the

far-western United States in particular, extending even abroad by way of a highly disciplined evangelicalism aided by the latest techniques in public relations. Mormonism is the religious analogy of the large American business corporation, and each draws its strength from the same power-sources that lie deep in the American experience.

This experience supports a curious sort of secularised Christendom, and the United States may be the last country on earth where a Christendom of whatever kind can be said to be alive and functional, if not completely well. The supreme icon of this is a 'born-again' head of state who teaches Baptist Sunday-school and insists on being addressed in a diminutive form of his Christian name, a pure American type without guile. Which means that he is largely without political power because his sort of Christian commitment renders him incapable of engaging in the labyrinthine arts by which such power has always to be exercised. All he possesses, besides a real personal goodness, may be only the appearance of power conferred by the celebrity of his office.

A certain celebrity, at least the appearance of affluence (which is not the same thing as financial security, much less real wealth), and more lately a sense of personal well-adjustment seem to be the main virtues cherished in such a secularised Christendom. They are at least the images of survival most frequently endowed with greatest value by the mass media, which control the discourse in such a society and thus the quality of that context of meaning from which its symbols emerge. And it is worth a lot of thought how frequently a church released from an old discipline, but not yet arrived at a new one, has seemed thoughtlessly unable to resist absorbing such questionable values. This is particularly true of its clergy. The presbyterate becomes a sort of celebrity which must be conferred by right on whomever feels a desire for it; the appearance of affluence is sustained by clerics at the Eucharist who display expensive personal jewelry even as the elevate simple and inexpensive pottery chalices; and the liturgy, together with certificates of specialisation (such as degrees in theology or counselling), affirm to them their own successful well-adjustment in a society that values such abilities. Such clergy often conduct the liturgy as though it were a television talk-show or a group session in spirituality, social action, or personal therapy.

The images of survival cherished by a secularised Christendom thus enter into the very heart of Christian polity by the inadvertance typical of those who possess only uncritical good intentions. Once lodged there, these images seem so benign as to be almost impossible to dislodge. A bishop must think very hard indeed before he is so bold as to remove a bejewelled, well-liked, and 'relevant' cleric from pastoral office and liturgical function only because the cleric has nothing at all to say about the gospel of Jesus Christ. Yet Jesus Christ was notoriously without the

appearance of affluence, oddly 'adjusted' to the religious relevances of his time, and finally deserted by those who were attracted to him only by the celebrity of his words and cures. He was too liberal for Pharisees and too conservative for Zealots, going too far for the first and not far enough for the second. He confused and scandalised all the apostles but one, who with his mother was alone with him as he finally redeemed the world, foregoing life that he might find it and give it without reserve to all. Catholic orthodoxy, which is first of all a liturgical criterion, has always arisen from this central mystery because this is all it has ever celebrated. Jesus Christ is the root-image of survival, an image that causes what it signifies because it is its own content.

6. CONCLUSIONS

From all this one might derive several conclusions.

First, it is idle to expect symbol and art to arise from a minimalist, a trivialised, or a merely educative or therapeutic liturgy. Such a liturgy will have to have symbol and art imported into it from elsewhere, an endeavour which in itself by no means assumes that the liturgy will escape either radical secularisation or becoming reduced to yet another facet of civil religion in countries of the 'first world'. While the liturgy does indeed make use of symbols and art drawn from the culture in which it exists, this is a secondary process of assimilation necessarily catalysed by the primary presence within it of Jesus Christ become, as Paul said, 'life-giving Spirit'. When this catalytic presence suffers any degree of restriction or dispersal in the worshiping assembly, it is inevitably restricted or dispersed in the assembly's liturgical act, which is *itself* the artfully enacted symbol or sacrament of that corporate presence in the worshipping assembly by faith and grace. The liturgy thus is said to 'use' symbols and art only to the extent that it is itself artful symbol in the first instance.

Second, artful symbolism in act need not be arcane, but it always demands high discipline. Rules, rubrics, laws, choreographies, or scores establish a stylistic floor beneath which performance may not fall without causing the given act to mutate into something different. Merely tapping out the rhythm of a Chopin sonata on a typewriter is not enough; reciting Prokofiev's *Romeo and Juliet* is an impossibility for there are no words; simply ignoring the Roman rubrics transmutes the Roman liturgy into whatever inept clergy may wish to make it. Yet neither does a merely wooden observance of rules automatically produce artful symbolic performance. Rules, scores, choreographies, and rubrics exist to be gone beyond, and here the even higher discipline of the tradition of performance must be entered into. Laws do not maintain style, but tradition does. Liturgically, rubrics must be insisted upon, but tradition must be

well known, its levels discriminated, and its agents both diversified and elegantly controlled.[5]

Third, egalitarianism breeds comradeship; élites breed style. The problem lies not in choosing between one or the other but in how best to use each in a coordinated service of the liturgical tradition—without reducing comradeship to the level of an alienated proletarianism or raising style to the level of a gnostic secret. A robust and self-confident church order seems to be the only general context within which such a balance can be achieved and sustained.

Fourth, and finally, there is much contemporary need for firm criticism, both positive and negative, of actual liturgical acts as they occur. This criticism must be constructive, and it should come from all quarters in the worshipping assembly, representing a variety of points in view. In particular, bishops who are moderators of worship in local churches can best serve a critical function not merely by being sensitive to a narrow range of rubrical neuroses, but by regularly presiding at excellent liturgies in their own cathedral churches. Good quality has a way of communicating itself by drawing the attention of all. Also, people who are exceptionally knowledgeable in liturgical matters bear a special responsibility to speak not only in general but to specific instances of correct and incorrect liturgical usage. For the artful symbolism which is the liturgy is never secured in the abstract or in general. It is accomplished in specific acts done by people in certain places at given times. Literary critics must know how to think clearly and to craft a good sentence, as an architect must know how to pour a good foundation and fit a door. No less must a person who loves the Church's worship be able to distinguish not good liturgy from bad so much as correct liturgical procedure from incorrect; and to tell why. For on this good or bad liturgy rests—as politics rests upon relationships, art upon craft, and symbol upon meaning.

Notes

1. See *Worship and Liturgy. Official Catholic Teachings* ed. James J. McGivern (Wilmington, North Carolina 1978).

2. Paragraph 41-42.

3. See Aidan Kavanagh *The Shape of Baptism. The Rite of Christian Initiation* (New York 1978) pp. 106-109.

4. See Frederick D. Willhelmsen *Christianity and Political Philosophy* (Athens, Georgia 1978).

5. See Constitution on the Sacred Liturgy *Sacrosanctum Concilium*, para. 26-32. Also the useful commentary of Thomas Richstatter *Liturgical Law Today. New Style, New Spirit* (Chicago 1977) pp. 61-87.

D

Enrique Dussel

Christian Art of the Oppressed in Latin America
(Towards an aesthetics of liberation)

THIS ARTICLE is an introduction to a subject of crucial importance, a theological aesthetics of liberation, and an outline of the problem.

1. 'ECONOMIC' STATUS OF THE EUCHARIST

In the Catholic liturgy the priest at the Offertory says the following prayer: 'Lord, we offer you this *bread* which has come from *working the earth*.' The bread which the celebrant holds up is not just symbolic, it is *real*. The work which produced it and the earth whose fruit it is are not symbolic, they are real. We must return to the reality which has often been hidden behind the symbol. It is the reality and not just the symbol 'which makes us think' (in Kant's or Ricouer's phrase).

The relationship between human beings and nature is work (*habodah* in Hebrew). Work is the intelligent effort by human beings to transform mere nature (the 'earth') and produce a 'fruit'. In the Bible the fruit of our labour *par excellence* is 'bread'—which is made from the Mediterranean crop, wheat. Thus the Eucharist presupposes *materially* the existence of 'bread' but its true status is *economic*. The economic relationship, as we understand it, is a 'practical-productive' relationship. The 'practical' relationship is that between two persons (me and you, man and God). The 'productive' relationship, as we have said, is the relationship between man and nature. The Eucharist is a relationship between two persons via the product of labour (and hence an economic relationship):

40

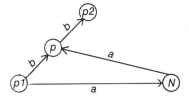

Work (arrow *a*) upon nature (*N*) results in a product (*p*) which is the condition for the possibility of the service of the cult (arrow *b*) man (*p1*) offers to God (*p2*). This cult or service (in Hebrew the same word is used as for work: *habodah*) paid to God is the offering of the product of labour. The cult is the *theologal economy*, the ultimate proof of Christian life. On the cross Christ made his body the cult 'object' and offered himself to the Father as a sacrificial victim. The victim (the dove, the ox or the martyr's own body) is the product of work and history consecrated to God. But even in Israel God made known his will. The best service of God is to give food to the hungry: 'I want mercy and not sacrifices' (Hos. 6:6). God is the absolute *Other*. The poor person is the absolute *other* in the system of domination. Giving the poor the real and *material* product of one's labour is to offer the absolute Other one's life and the product of life for the reproduction and growth of life. The condition of a Eucharist acceptable to God is that the poor should *materially* eat. Thus justice in historical economic systems is the preliminary requirement for the celebration of the liturgy, because the Eucharist is the celebration in history of the perfect, Utopian economy. It is the banquet which requires that all who share it have satisfied their *material* hunger through historical justice. The Eucharist is a reminder of justice, it celebrates justice and foreshadows the justice of the Kingdom (by justice we mean also salvation and liberation). Thus the Eucharist is the critical yardstick against which every historical system of economic injustice must be measured.

2. A THEOLOGY OF PRODUCTION?

The theology of liberation, like all Christian theology possible today depends totally on a preliminary 'theology of production' (i.e., productive *creation*). From ancient times philosophy—and theology too—have discussed the 'work of art'—as Heidegger did for example in his *Der Ursprung des Kunstwerkes*.[1] The ruling class always paid attention to the works of artists and to art in general, from the Greeks (with their *techné*) and the Middle Ages (*ars*) to the aesthetics of Baumgarten. From his bourgeois standpoint Kant expressed it thus: 'The art of man is also distinguished from science as the practical faculty from the theoretical, the technical from the theoretical. . . . Art is also distinguished from craft (*Handwerke*). Art is called liberal, whereas craft is paid. Art thinks of

itself as a game . . . whereas craft thinks of itself as work (*Arbeit*), that is to say as an occupation in itself disagreeable, and irksome whose only attraction is its effect, the wage.' (*Kritik der Urteilskraft* 43, A 171).

Continuing via Hegel's *Aesthetik* to Heidegger, we find that the 'aesthetic' is the *clean* part of production, belonging to the ruling class and the geniuses, and leaving in the dark world of the irrational, contemptible, irksome and economic, the paid work of the worker under capitalism, whence however, the oppressed produce the *real* and *material* bread of the Eucharist (whereas the bourgeois artists build the fine churches, the stained glass windows, the statues of the saints, and publishers make fat profits with aesthetic missals etc.). On July 25 1976 the bishops of Gautemala wrote after the earthquake that destroyed the city and many great works of colonial art: 'From the historical point of view the cultural and artistic loss is irreparable. However all this was not the chief or only wealth of the Church. The Church does not get its strength or its true wealth from churches or from works of art collected through the centuries.'[2] We are not despising 'sacred art' but we want to put it in its place within a 'theologal economy' in which the aesthetic is not of primary importance in the 'theology of production'. First comes the daily work of the labourer. The most important thing is productive work for the essentials of life: food, clothes, housing (see Matt. 25:35) and only after this comes everything that improves the *quality* of life: enjoyment, delight, admiration. The million and a half human beings who are hungry and almost naked living in the satellite city of Nezahualcoyotl in Mexico and in the Indian towns, need life first (right to work, eat, basic necessities) and aesthetics later.

A 'theology of production' should think of the universe and nature as a 'product' of the divine vitality and God's creative act as an expression of himself as love. And it should think of man as a 'productive subject' (not an *ego cogito* but an *ego laboro*) who in producing the goods required for the *basic necessities* of human life creates the conditions for the celebration of the Eucharist: 'Take, *eat*, this is my body' (Matt. 26:26).

Need (unfulfilled negativity) is a tension towards the joy of satisfaction and fulfilment, and if this satisfaction is *just*, it is a foretaste of the kingdom of heaven.

A 'theology of production' is the *matter* (Christian materialism has nothing to do with Engels' 'cosmological' materialism, which in any case contradicts 'historical' materialism) of a theology of the sacrament.

3. PRODUCTION, ART AND SOCIAL CLASSES

It is well known that the 'Frankfurt School's' break with Heideggerian thought was, among other things, on aesthetics. Although the *Kritische Theorie* never emerges from a certain aestheticism into the broad field of

human production in general, that is to say, to the point of valuing work highly enough,[3] Theodor Adorno at least reached the point of saying: 'Music—one of the arts—is not a manifestation of the truth (as Heidegger thinks) but it is in a real sense an ideology.'[4] If art is 'ideology', this means it is *one* aspect of the total productivity of a social class.

In fact a social class is defined essentially by its material *substratum*: a certain type of work. The type of work determines (but not absolutely) the customs and culture of a human group. If it is true that there is a 'technical division' of work (for example between engineer and labourer) this means that the worker is situated in an historico-social division. In post-feudal European society, for example, the social classes are determined by the fact that some sell their productive labour and others hold the private property of capital. Among productive human actions of all kinds, 'artistic production' has a special place. An artistic action always remains connected (not absolutely) to the social class of the artist that performs it. Likewise the ideal of beauty or fidelity is closely linked to the aesthetic value system of different social classes. For example Latin American neo-classicism (which began to appear from the beginning of the nineteenth century in the struggle against Spain) represents the irruption of a bourgeois oligarchy simultaneous with the expansion of Anglo-Saxon capitalism in Latin America. The baroque, on the other hand, corresponded to Spanish mercantile and pre-industrial capitalism. That is to say that there are not only *periods* in art, but in these periods there is a *contradiction* between the art of the ruling class and the art of the oppressed classes. It is obvious that triumphant, hegemonic, dominant art is the art of the class in political, economic, ideological and therefore artistic power.[5] Thus through its objective content, art is 'in a real sense an ideology'. Expression in objects (words, images, sculpture, buildings etc.) manifests, justifies or criticises the given structures of a society. Art occupies a central place in the ideological struggle in the system (as *dominative art* when it reproduces and supports the system, as *liberation art* when it expresses the oppressed classes and offers models of the new and still utopian world). As one aesthetician put it: 'If the future revolution is planned only for economic reasons and not also from the rise of a new sensibility which seeks new objectives and priorities, it will not be a revolution, and the artist is very important to an authentic revolution.'[6]

4. RELIGIOUS ART AND OPPRESSED CLASSES IN LATIN AMERICA

In general the history of art in Latin America well into the nineteenth century is fundamentally the history of religious art. At the same time it is the stage of a real 'struggle between the arts' of domination and of the oppressed.

The symbolic and mythical 'production' of the people, as Hugo Assmann pointed out, is the central moment in artistic production, secondary to the production of *bread*, but central in regard to other aesthetic productions (songs, poems, images, churches etc.). We shall take an example to illustrate the problem of the struggle between dominators and dominated in the three periods of Latin American religious art (pre-Hispanic, Spanish colonial and the period of dependence of Anglo-Saxon capitalism, until its defeat).

(a) 'Quezalcoatl-Tonantzin' as symbols of the oppressed classes

In the ninth and tenth centuries A.D. a barbarous people of the Pima-Nahuas group invaded the high culture zones of Mexico. These were the Toltecas. Their second king, a young priest, Quezalcoatl-Topilzin, reigned in Colhuacan. He was full of wisdom, patience and holiness. He was obliged to abandon Tula and go north, promising to return from the east and, according to tradition, changing into the evening star (Venus):

'The Toltecas were wise thanks to Quezalcoatl,
the Toltecoyotl (all the arts combined) was his wisdom,
everything came from Quezalcoatl,
the Toltecas were very rich and happy.'[8]

When the Aztecs conquered, the Toltecas became an oppressed class, like the Greeks in the Roman Empire. But the Aztecs (like the Romans) had a guilt complex and feared the return of Quezalcoatl—who was particularly honoured in Cholula, the land of the Tlaxcaltecas, the first allies of Hernan Cortes. Quezalcoatl became the expression of the messianic hope of the oppressed in the Valley of Mexico. When the Spaniards came from the east, Moctezuma the Aztec Emperor himself trembled with fear—the hope of the poor was being fulfilled: 'It truly must be certain,' wrote Bernal Diaz in his *Historia Verdadera de la conquista de la Nueva Espana*, 'that we are they whom their predecessors long ago said would come from the sunrise . . .'[9]

Likewise the farmers of the Valley were dominated by the Aztec nomads and warriors. Every year the oppressed farmers made a pilgrimage to the great sanctuary of the Earth Mother, the mother of the gods: 'The first of these goddesses,' says Sahagun OFM in his *Historia General de las cosas de Nueva Espana*, 'was called Cihuacoatl, which means Serpent's Wife (*sic*) and she was called Tonantzin which means our mother.'[10]

To which he adds in another place: 'One of these cult places is here in Mexico, where the hill called Tepeyac stands . . . here there was a temple dedicated to the mother of the gods who was called Tonantzin . . .'[11]

Quezalcoatl-Tonantzin was a 'fundamental pair in the Mexican pantheon, whose Creole avatars are inseparable. From the pre-Colombian past they are linked together as the two faces, male and female, of the creator first principle'.[12]

(b) St Thomas, apostle and the Virgin of Guadelupe as symbols of the liberation of the oppressed Creoles

On April 15 1549, Manuel de Nobrega related in Brazil that 'a trustworthy person told me that the cassava with which they make the bread in this country was a gift of St Thomas'.[13] The same Jesuit relates having seen the apostle's footprints imprinted on a rock. ('Not far from here there are footprints imprinted on a boulder.')[14] In Patagonia another Jesuit found other footprints of the apostle. In Mexico Quezalcoatl means 'twin' (the 'dual' origin of the universe), just as Thomas does in Greek (dual, divided, twin). Moreover the Toltecan god had a 'cross' on his pointed hat (because he was the god of the winds from the 'four' cardinal points. This cross and its relation to the Great Flood and 'so many other signs' made Fr Diego Duran, OP, think that the Toltecan priest and king—and thus god—was the apostle Thomas, no less, who went to India from Palestine (it was known that there were 'Christians of St Thomas' in Mylapore), and thence had come to Mexico: 'God sent his holy apostles all over the world to preach the Gospel to every creature . . . and it was Topiltzin who came to this land, and according to the story told about him, he was a stonemason who sculpted stone images with curious workmanship, and we also read this about the glorious St Thomas.'[15]

This story deprived the Spaniards of their justification for the conquest of America: the Christian Gospel had been preached there before they came. This tradition, referred to constantly by the 'Creoles' (people born in America) became the ideological banner against the 'Gachupines' (Spaniards born in Spain). Tovar, Acosta, Torquemada and others are aware of this tradition. However, Gregorio Garcia wrote the crucial work: *Predicacion del Evangelio en el Nuevo Mundo viviendo los apostoles* (Baeza, 1625). If this was true, it gave the 'Creoles' the theological (ideological) right to fight colonialism from the beginning of the seventeenth century. Belief in St Thomas-Quezalcoatl was the first affirmation of national consciousness by the American Creoles, a class oppressed by Spanish bureaucracy. The apostle Thomas rose up against the apostle James, the saint venerated by the Spaniards in their struggle for liberation from the Arabs from the eighth century onwards. Thus Hernan Cortes took as his war cry against the natives: 'St James against them! . . . After the battle they were afraid of our horses and shots and swords and crossbows and our brave fighting and above all the great mercy of God.'[16]

With good reason, St James was thought of by the natives as the god of

war and the horse of St James—as represented in the popular art of the Reconquest—was venerated more than the horseman himself.

In the 'Sad Night'—as history called it, when the Aztecs were on the point of defeating the invaders—Cortes prayed to the Virgin of Remedies, always the protector of the Spaniards, conquerors, rulers, white. And just as the Creole Thomas rose against the Spanish St James, so the Virgin of Guadalupe rose against the Virgin of Remedies. Everything began thus: 'Wanting to repair this great damage, our first religious (Franciscans) decided to place a church in Tonantzin, near Mexico, to the Most Holy Virgin who is our Lady and Mother.'[17]

An image of the Virgin of Guadalupe—who liberated Spain of the Reconquest and guarded the warriors who fought the Moors—rapidly gained the homage of the natives. They came to Tonantzin by tradition, and continued to venerate the mother of God. On the Virgin's shoulders shone the rays of the sun (the Sun, Huitzilopochtli, was the supreme god of the Aztecs); the blue of her cloak was the sacred colour of the gods, the sky (teotl); the moon indicated maternity and the earth; she was a mother like Tonantzin; she conquered the serpent (like Tonantzin who conquered over a cactus like the eagle the serpent) . . . in fact she could be clearly decoded by pre-Hispanic codes (but of course with different meaning than for the Christians or the Spaniards).

The Virgin of Guadalupe of Tepeya was thus the protector of oppressed native class, she especially helped in the frequent floodings of the Valley and in the terrible plagues which decimated the Indian population.

But it was not until 1648 that the 'Creole' Bachelor of Theology, Miguel Sanchez, a Mexican and therefore oppressed by the Spaniards, wrote his *Imagen de la Virgen Maria Madre de Dios de Guadalupe milagrosamente aparecida en Mexico* (printed by Calderon, Mexico, 1648). The author held that from all eternity God had ordained the appearance of the Virgin in *Mexico*, as could be clearly seen from chapter 12 of *Revelation*. In fact the text reads: 'A great portent appeared in heaven, a woman clothed with the sun' (Rev. 12:1). For the author this was precisely the Virgin of Guadalupe clothed in the rays of the sun. 'But the woman was given the wings of the great eagle that she might fly' (12:14), meant the 'Aztec eagle' the imperial sign of the Nahuas. 'The serpent poured water like a river out of his mouth after the woman, to sweep her away with the flood' (12:15), meant Lake Texcoco, where Mexico City was situated. In the end the woman conquers the serpent (who had been the 'sign' for the Nahuas to found Mexico City in the middle of the lake) etc. Miguel Sanchez even said that the Guadalupe image was 'native to this country and the first *Creole* woman' (p. 195). 'God fulfilled his admirable plan in this land of Mexico, conquered for

such noble ends' (p. 49). Creole national consciousness, of the oppressed against their oppressors, depended much more on this tradition than on the reading of the authors of the Enlightenment. Patriots were imprisoned by the Holy Inquisition for their devotion to the Virgin of Guadalupe, like Fray Servando de Mier in the eighteenth century. Even in 1800 a subversive group of Creoles armed against the Spaniards called themselves the *Guadalupes*. When the parish priest Miguel Hidalgo, the liberator and founder of Mexico, sought a flag for the popular armies, which he led against the Spaniards in 1810 in Michoacan, by common consent they adopted the standard of the Virgin of Guadalupe, which was used in processions. And the priest Morelos, the leader who succeeded Hidalgo told his soldiers fighting for liberation to wear in their hats 'a device of ribbon, tape, linen or paper declaring their devotion to the most holy image of Guadalupe'.[18]

Even in the Mexican revolution of 1910 the peasant leader Emiliano Zapata, who destroyed churches, took as his banner when he was occupying Cuernavaca, the Virgin of Guadalupe. The leader of the agricultural unions in California, Cesar Chavez (of the UFWOC) also took the Virgin of Guadalupe as the insignia of his union.

Thus St Thomas versus St James, the Virgin of Guadalupe against the Virgin of Remedies was a struggle between religious symbols, a class struggle, a contradictory art in which the poor and oppressed produced their own forms and used them against the dominators.

5. SOME EXAMPLES OF THE RELIGIOUS ART OF THE OPPRESSED

It is a difficult task to find works of art which are 'the religious art of the oppressed', because, since they are oppressed, their works are easily destroyed, because of the materials used, their lack of significance for the ruling aesthetic system, because they are in out of the way places etc. However, there are clear signs of the presence of this art throughout the Church's life.

Think, for example, of the famous Latin American Christs, which some ascribe to popular *tremendism* (the grotesque). These Christs have deep wounds, enormous clots of blood, infinite sadness in their big eyes, great thorns, and a realism which is shocking in the pain portrayed. There is the 'Lord of Patience' in Santiago de Xicotengo,[19] who is sitting down, defeated, with his head resting in his hands and his arm on his knee. How different from the triumphant risen Christ with great wide-open peaceful eyes, the *Pantokrator* of the Byzantine mosaics. In Byzantium he is the Christ-emperor of the ruling classes, in Latin America he is the suffering Christ of the oppressed classes. 'Christs representing the established

power and Christs representing the impotence of the oppressed are the two faces of the Christologies.'[20]

These suffering, *tremendist* Christs are the brilliant and authentic expression of an oppressed people, *identified* with Christ crucified and not yet risen, defeated by the Power of this World . . . and the hope of liberation. Francisco Goitia in his work *Tata Jesucristo*[21] shows in the praying faces of the natives the infinite pain and deep hope in their prayers addressed to the suffering Latin American Christ.

It is known by art restorers that frequently, when they treat sculptures of Christ crucified made of maize flour and beautifully painted, their internal vertebral structure is a stone icon of a pre-Hispanic deity. Thus the popular religious sculptor thinks of Christ crucified as the sublimation of his ancient gods, who were conquered by a Christ who was also conquered. In this double defeat, which is not just morbid masochism, they affirm the hope always deferred, but stronger than life itself, for liberation.

In the great colonial churches—which include some of the best expressions of the baroque, such as the splendid Jesuit churches of Tepozotlan in Mexico and in Quito with its marvellous Creole art—the natives introduced innovations into the decoration which became works unique of their kind, like the interior of the Church of St Mary of Tonantzintla in Cholula,[22] where the plaster decorated in the native style is truly amazing. In other cases the native artists introduced modifications into the specifications of the architects, as in the Church of San Ignacio Mini, of the Jesuit settlements in Paraguay, which was finished in 1717. This church has 'such decorative richness that it covers the tympanum, cornices, counterpilasters with stylised leaves, eggs, ribbons, pearls and other motifs used with complete disregard for the order and harmony in classical architecture'.[23] Thus the artistic work of the oppressed is present in the works of the Christian oppressors. As well as visual art there is a vast field of popular art of the oppressed in music. There are carols in all rhythms (South American, Brazilian, Central America, Caribbean), 'Creole Masses' now stylised (like those of Ariel Ramirez) or the 'Mariachis' Mass of Cuernavaca Cathedral, among many others. Popular religious songs also express the sad and painful reality of the oppressed classes. Some display a tragic resignation, others are simply the artistic religious expression of the reality:

Friends, men are born
to suffer,
till death comes
and beats them down.[24]

Death is ever present in these popular religious songs. But this death is

lived with, even joked at, although it is treated with respect. It is called 'St Death' in Paraguay, and in Mexico he is 'conquered' on the Day of the Dead when each child receives a present of a skull made of sweet bread with his name on it, which they play with and then eat with delight. This 'skull' is not frightening. For those who live the life of the oppressed, death is not so terrible. As a Sandinista guerrilla recently expressed it:

Death come secretly,
don't tell me when
so the pleasure of dying
won't bring me to life again.[25]

Clearly great artists can give these popular expressions unexpected brilliance, as in the case of Ernesto Cardenal—the artistic vanguard of an oppressed people: 'I believe that the contemplative, the monk and even the hermit, is really a revolutionary. He is also bringing about social change. And he also bears witness that as well as social and political changes there is a transcendent reality, beyond death. I believe it is important that there should also be people to remind mankind that the revolution goes on also after death.'[26] Likewise the great José Gaudalupe Posada uses the theme of death on the Day of the Dead and the peasants' death-in-life to formulate a political critical art of the 'skulls'.[27] Social, religious and eschatological criticism. And great Mexican muralists like Diego Rivera, José Clemente Orozco, David Sigueiros and Bufino Tamayo, who are anti-Catholic but non the less 'religious' in their chosen themes, give organic expression to popular art with the revolutionary techniques they use in their magnificent works.

Inside their homes, in peasants' cottages and the tin huts in the wretched shanty towns of the big cities, beside the image of the Virgin of Copacabana in regions which belonged to the Inca Empire or the Virgin of Lujan in the South, or many others, there are photos of relations (who, when they are remembered, protect from 'evil spirits'), and the lighted candle signifies the presence of the family. The 'family altar' is an art of the oppressed which expresses the longing for security and justice in an intimacy not violated by the capitalist system outside.

The numerous processions to popular sanctuaries—which the oligarchy does not join in—where special saints are implored with interminable prayers, movements of body, head and lips and offerings, for daily bread, health, work, safety . . . which the ruling system has denied the oppressed.

This art of the oppressed is an expression of bitter need, but it is also a protest and hope of liberation. . . . Within popular Latin American messianism (particularly characteristic of the Brazilian *sertao* with its saints, prophets and messiahs . . . persecuted and killed by the police and even

by parish priests at one time) there exists an authentic creative *productive* power, which reveals the historical liberating force of the poor.

6. AESTHETICS OF THE OPPRESSED AS LIBERATION ART

It is important not to confuse three kinds of Christian artistic expression:

(*a*) *The art of the ruling classes* or 'aesthetics of domination' (which includes the art of the *masses* or what Arnold Hauser called *popular* art, as opposed to the authentic art *of the people*.[28] This art is triumphant and can be seen in the restored German churches (glass doors, bronze decorations, perfect lighting, organs with wonderful acoustics etc.).

(*b*) *The art of the oppressed classes* or 'popular art produced by the working class, *liberation art*' as Nestor Garcia Canclini[29] describes it, an art which needs to be discovered and valued. Of course the art of the oppressed at a certain period (for example the Latin American *Creole* art of the eighteenth century) can be transformed into ruling class art (of the natives and workers in the nineteenth and twentieth centuries).

(*c*) *The art of the prophetic Christian vanguard* which is an integral part of the people's struggle. Among others we find here Ariel Ramirez in music, Ernesto Cardenal in poetry, the muralists in numerous parishes, centres and popular Christian meeting places etc. Both the art of the oppressed class and of its artistic vanguard are *liberation art*, which in Latin America today is revolutionary,[30] and supplies the essential requirement for the celebration of the Eucharist.

The 'theology of production' as part of the theology of liberation and which includes the aesthetic theology of liberation, should first investigate the economic conditions for the production of *bread* to satisfy the basic needs of the people—and only then can the Eucharist be celebrated. Secondly, it should study the *aesthetic* production of works of art which express in their 'fidelity' to the face of the oppressed (the bleeding Christs of popular Latin American *tremendism*) critical, prophetic and eschatological 'beauty'. This *fidelity* of expression of the poor, of Christ tortured and crucified, criticises the governing dominant 'beauty' of the system.

Christian *liberation art* of the oppressed classes, like the people in *Exodus* who expressed themselves in the simplicity and poverty of the nomad Tabernacle rather than in the splendour of the Temple in Jerusalem (criticised by Christ: Luke 19:46; 21:6), makes the *economy* the foundation of *symbols*. In developed capitalist countries there appears to be *freedom, bread* and *art* to celebrate the Eucharist, even though some think that really 'it is sacrificing the son to his father to take from the poor to offer sacrifice' (Ecclus. 34:20). The *bread* stolen from

the Third World cries to heaven. In developed socialist countries in Eastern Europe, like Poland, the people have *bread*—which is important—and some are asking for *freedom* to celebrate the Eucharist. In Latin America the people have no *bread* to celebrate the Eucharist, because they are hungry, and only those in power have *freedom*. The oppressed people do not have the freedom to create the new world they need (bread and works of art) and which the Eucharist requires as a *preliminary condition* for its celebration. Only the oppressed people and a heroic prophetic vanguard risk even their lives, to create the new . . . as in Nicaragua today (June 1979), making their own bodies (the 'flesh' of the sacrifice) the living 'symbol', manifestation and witness (*martyrs*) of the kingdom: the new *bread* of the future Eucharist.

Translated by Dinah Livingstone

Notes

1. Klostermann *Holzwege* (Frankfurt 1963) pp. 7-68.

2. Pastoral letter of the Episcopal Conference 'United in hope' in *Praxis de los padres de America Latina* (Bogota 1978) p. 791.

3. As does, for example, Georg Lukacs, not so much in his *Eigenart des Aesthetischen* (Berlin 1963) but more particularly in his *Zur Ontologie des Gesellschaftlichen Seins*, XIII(XIV 'Die Arbeit' (Berlin 1973).

4. *Einleitung in die Musiksoziologie* (Frankfurt 1962), beginning of chapter 4. Herbert Marcuse in his recent work *The Aesthetic Dimension* shows how art cannot be reduced purely to the 'ideological' dimension, because it has a certain 'autonomy' and selfhood, but this autonomy, being 'relative' does not deny art's material conditioning. In this article we have concentrated more on the 'relative' than the 'autonomous' in art. See Theodor Adorno *Aethetische Theorie* (Frankfurt 1970).

5. See Nicos Hadjinicolau *Histoire de l'art et lutte des classes* (Paris 1973). The author confines art unilaterally to ideology, and this reduction describes the 'relative' in art well but neglects the 'autonomous'—(although this autonomy is of course also relative). We discussed these questions in our *Filisofia de la poiesis* (Mexico 1978). It is worth pointing out that Hegel's *Aesthetics* is the best description of the aesthetics of the ruling classes: 'In the forms (*Gestalten*) it uses, art selects one stratum in preference to others, the stratum of the princes (*Fürsten*) . . . Perfect freedom of will and production (*Hervorbringens*) cannot be achieved except in the representation of principality (*Fürstlichkeit*).' *Vorlesungen über die Aesthetik*, I, III, b, II, I, a; *Theorie Werkausgabe* (Frankfurt 1970) XIII p. 251.

6. Marta Traba *Dos decadas vulnerables en las artes plasticas latinoamericanas, 1950-1970* (Siglo XXI, Mexico 1973) p. 179.

7. 'El cristianismo, su plus valia ideologica' in *Theologia desde la praxis de liberacion* (Salamanca 1973) pp. 171-202, especially 'La operacionalidad de los universos miticos y simbolicos' pp. 103-195.

8. *Codice matritense de la Real Academia de la Historia*, Sahacun, sheet 176, reverse side.

9. (Mexico 1955) Book I chap. 89 p. 266.

10. ed. Garihay (Mexico 1956) Book I chap. 6 I p. 40.

11. *Ibid.*, Book XI, Appendix 7-; III p. 352.

12. J. Lafaye 'Quetzalcoatl y Guadalupe' Fondo de Cultura Economica (Mexico 1977) p. 299.

13. *Monumenta Brasiliae Societatis Jesu* I (1538-1553) p. 117.

14. *Ibid.*

15. *Historia de las Indias de Nueva España*, chap. 79 (Mexico 1880) II p. 73.

16. Bernal Diaz del Castillo, *Historia Verdedera,* chaps. 52 and 63.

17. Torquemada *La Monarquia Indiana* (Mexico 1723) II Book X, chap. 7 pp. 245b-246a.

18. 'Sentimiento de la Nacion' (1814 copy) in *Poletin del Archivo General de la Nacion,* 2nd series, IV, p. 3 (1963).

19. M. E. Ciancas *El arte en las Iglesias de Cholula* (Mexico 1974) p. 164.

20. Hugo Assmann 'The power of Christ' in *Frontiers of the Theology in Latin America* (New York 1979) pp. 149-150.

21. Oil painting hanging in the Palacio de Bellas Artes, Mexico, dated 1927. See Justino Fernandez *A guide to Mexican Art* (Chicago 1973) p. 375. Consider the 'horrible' suffering expressed by the 'Cristo de la Columna' in the Church of Santa Prisca (Taxco, Mexico). Cf. Leopoldo Castedo *A History of Latin American Art* (New York 1969) p. 134.

22. L. Castedo *ibid.* p. 131.

23. Romualdo Brughetti *Historia del arte en la Argentina* (Buenos Aires 1970) pp. 133ff.

24. Hose Hernandez *Martin Pierro,* verses 1688-1692.

25. J. A. Carrizo *El tema de la invocacion de la muerte* p. 720. See my *El catolicismo popular en Argentina* (Buenos Aires 1970) pp. 133ff.

26. *Santidad de la Revolucion* (Salamanca 1976) p. 21. The artist and prophet takes the people's *contempt* for death and gives it its radical sense.

27. See L. Castedo in the book cited in note 21, at p. 357.

28. *Philosophie der Kunstgeschichte,* chap. 5.

29. *Arte popular y sociedad en America latina* (Mexico 1977) p. 74. Here 'popular art' is the same as Hauser's 'art of the people'.

30. David Siqueiros says 'Criticism must be complete so that useful lessons can be drawn from it with the aim of making a real *"revolutionary art"* ('El camino contrarevolucionario de Rivera' in *Documentos sobre el arte mexicano* (FCE, Mexico 1974) p. 54.

Boka di Mpasi Londi

Freedom of Bodily Expression in the African Liturgy

I HAVE only one aim in this article and that is to bring to light the fundamentally sacred and communicative nature of bodily expression, and particularly, in Africa, of festive dancing,[1] and, on this basis, to examine the merits of its claim for an integrated place in the liturgy. In African culture especially, dancing would seem to be the primordial and the most sacred of all man's forms of artistic expression and indeed the rite *par excellence.* If this is so, would it not be depriving the liturgy of its essential mode of expression if dancing were eliminated from it? In Africa, an encounter with the living God in communion with his people through dancing is a worthy and legitimate way of celebrating the incarnation of the Word and the presence of Emmanuel—God-with-us by justifying that incarnate presence. It is not difficult to understand the almost prophetic statement made by the late Cardinal Daniélou: 'I simply do not know how the black people could praise God without dancing because dancing is so deeply embedded in their whole being that it forms an integral part of their civilisation. In them we rediscover the liturgical meaning of the sacred dance. . . . They need an incarnation of Christianity which is different and which is in accordance with their instincts and their whole being'.[2]

The Constitution on the Liturgy, *Sacrosanctum Concilium,* the first publication of the Second Vatican Council (4 December 1963) gave back to the human body its freedom to praise its creator in many different ways: 'By way of promoting active participation, the people should be encouraged to take part by means of acclamations, responses, psalmody, antiphons and songs, as well as by acclamations, gestures and bodily attitudes. And at the proper times all should observe a reverent silence.'

53

A little later in the same document, we read that allowance should be made 'for legitimate variations and adaptations to different groups, regions and peoples, especially in mission lands'.[3] Statements such as these could only have a liberating and very stimulating effect. It should not be forgotten, however, that Vatican II, far from being the point of departure here, was the summit of a long and difficult movement marked by several important signposts: Pius XI's *Divini Cultus* (1929) and several of Pius XII's encyclicals: *Mystici Corporis* (1943), which formed a solid basis of theology for the later *Mediator Dei* (1947) and *Evangelii Praecones* (1951).

1. THE BREAK BETWEEN THE PRECONCILIAR LITURGY AND THE LOCAL CULTURE

The paths leading to the emergence of a new African liturgy at Ndzon-Melen (Cameroon) and a new Mass in the Zairian rite (Zaire) have been discussed at some length,[4] with the result that we do not have to retrace in detail the developments in liturgical studies before the Second Vatican Council. All that we need to do here is to point out, in broad outline, the main movements in the liturgy from which the Constitution on the Liturgy has released us.

In considering the psychological reactions to this liturgical behaviour, seen here in the socio-cultural context, it is, I think, important to note, on the one hand, the embarrassment caused by what may be rough physical initiation and, on the other, the unease and feeling of cultural oppression experienced as the result of a rough break between liturgy and life in the concrete.[5] This break is in fact a radical one—on the one hand there is a frozen, encaged and inhibiting liturgy, imported with its apparatus of sacred signs from the distant north and, on the other, the local traditional cultural pattern, with its exuberant symbolism and its quickly communicated vitality, excluded from the liturgy.

This radical break between liturgy and life has had three important consequences. The first is that the liturgy became an isolated action, necessarily confined within narrow limits of a given space and time. This time is one hour per week, per month, per term or even per year, depending on the place. It is, of course, negligible in comparison with the rest of the time—not consecrated because it is not adopted—that passes outside the action of the liturgy. The space is, of course, a church, which is a very minute and enclosed space in comparison with the great world within which day to day life is spent. Then there is the cultural separation of the liturgy from life. Most of the official symbols used—words, gestures and attitudes—were, in the past at least, not always readily understood. To make them more open to understanding, various commentaries and transpositions were used. Many of these changes of position were necessary because of local customs. It was, for example, regarded in Africa as a

crude, even obscene gesture and an insult when the priest bowed low with his back to the congregation in the earlier liturgy, as he did, for example, during the *Confiteor*.[6]

So many aspects of African life and thought which are so precious to us have, moreover, been absent from the action of the liturgy. These include the African's ancestral sense of his environment, his vision of the world and his total conception of man, in whom he sees no separation between body and soul, between the individual and the community and between the community and the cosmos. In this vision, the African is conscious of no division between the visible reality and the reality that he cannot see, in other words, between the profane and the sacred. Yet all this cultural inheritance was lacking, so it seemed to Africans, in the liturgy.

The opportunity was therefore missed to make the liturgy the special place where structures could be baptised and values evangelised and where both could be traced back to their Christian sources. Liturgy might have been able to act like leaven in the lump and have an influence on the spread of Christianity within the African culture. This influence, however, was impeded by division between the sphere of liturgy and the environment of ordinary life. The Christian felt frustrated because he had to tear himself away from his own world in order to enter, for an hour, a space that was regarded as sacred and where a ceremony that was a spectacle took place. What generally happened was that the believer was present at the action of the priest, who was always busy. He was not able to take part himself. He was forced to be a spectator and was not a committed actor or participant. This accounts for the strong recommendation of the Council: 'Christ's faithful, when present at this mystery of faith, should not be there as strangers or silent spectators. On the contrary, through a proper appreciation of the rites and prayers they should participate knowingly, devoutly and actively.'[7]

When we heard the Second Vatican Council say that the liturgical renewal was to be based on 'full, conscious and active participation',[8] it was like hearing the hour of our deliverance sounding, the hour when, in the freedom of the restored children of God, we too are invited to restore the inalienable traditional African values by integrating them into our faith through our living liturgy. It is significant that words like 'restoration', 'renewal', 'progress' and so on, on the one hand and 'participation', referring the whole people of God on the other, are used so frequently in the conciliar document on the liturgy and that the need to make an effort is equally stressed.[9]

2. THE PLACE AND FUNCTION OF THE BODY IN THE AFRICAN VIEW OF MAN

In stressing the need for the whole people of God to participate in the liturgy, Vatican II came very close to the most profound and precious

E

desires of African Christianity. It would take too long for me to discuss even briefly the many studies that have dealt with the African understanding of what is meant by 'participation'.[10] I can only mention two here: *La Philosophie bantoue* by Fr. P. Tempels and *Le Visage africain du christianisme* by Fr. V. Mulago.[11] The first author stresses the living force of the African people and the second emphasises their living communion. Both, in fact, deal with the idea of relationship and participation.

This participation forms the basis of the community's cohesion and at the same time justifies the solidarity that follows from it as well as all the connected African values praised by Paul VI in his message *Africae terrarum*.[12] It is not difficult to guess that the liturgical renewal urged by the Council's document was welcomed by African Christians as an initiative giving them freedom of bodily expression in the liturgy. In accordance with our distinctively African way of speaking, we speak of the liberation of the whole man or of man as such. We do not, generally speaking, think of man as consisting of two almost separate parts, body and soul. We think of him as a *muntu*, as a personal living whole or as a capacity of communion. The human body is not seen as a simple wrapping, like the bark of a tree, but as the essential place, the inherent place of life and its expression. It is eminently the mediation of communion.

It is through the body that the person is in communion with the surrounding material world. It is in communion with the air, for example, by breathing, with the vegetable and animal world by eating and drinking and with the world of human beings by what is expressed, for example, in the words sensitivity, sympathy, welcome, hospitality, compassion, understanding, solidarity and, in a word, love. It is also through the body that the human person feels himself to be in communion with the spiritual world.

This spiritual world includes the supreme being, God, and the intermediate spirits, both benevolent and malevolent, who live in solidarity with the ancestors of men. It is their relationships with the world that brings into being an entire network of spiritual influences between 'souls', unequally strengthened from above, some, in other words, being more powerful than others. Finally, it is through the human body that the *muntu*, the whole human person, is in communion[13]. It is hardly surprising, then, that God became flesh in order to be intimately and totally in communion with man. In this sense, then, existence is 'being with' and living is being in communion with. Following Aristotle, Thomas Aquinas saw life as consisting of movement. The African, on the other hand, sees it as consisting of communion or inter-relationship.

This is the vision which prevails even now, more, of course, in African villages than in the towns. It is a view of the world, of man and of the human body which is inculcated into children by the traditional form of

education in riddles, stories of various kinds and rhythmical games which shape the children's way of thinking and assure that this way of thinking will continue to be handed down. By virtue of their structure, these stories, games and conundrums combine to produce in the child an experience of communion with the environment in which he lives so that he thinks of himself, especially in adolescence, as a universe in miniature. What takes place in him is the development of a consciousness of being, in and through his body, in a permanent relationship with an immense world that is not in any sense limited to objects and phenomena that can be perceived by the senses, but goes far beyond this.

Riddles and conundrums are the most effective way of inculcating this consciousness. It is not difficult to recognise from a few current examples of such traditional formulae taken from the Bakongo ethnic group (widespread in Angola, Congo and Zaire) how this way of thinking, in which the creator, God, is placed in the centre of the whole of creation, penetrates imperceptibly into the child's mind and how, in this way of thinking, the body as it were sums up the whole of the surrounding universe and brings the whole of the surrounding universe and brings the whole of man into communion with it. In these conundrums, the universe is explored in reference to God who is its creator and in reference to the human body who sums it up in miniature. Man is, for example, in his body a field created by God where nothing grows (the palm of the hand). Or he is a forest created by God which is always being stripped of trees that grow again and again (the hairs of the head). Or he is two trees planted by God; they grow on each side of the house, but never see each other and never meet (the ears).[14]

3. THE SPIRITUAL AND MYSTICAL SIGNIFICANCE OF THE DANCE

Rhythmical movement and especially dancing are the specific ways in which contact with the spiritual world is expressed in the human body, which, as we have seen, is thought in Africa to be the place *par excellence* of communion with man's environment. It has been observed that the African baby makes little rhythmical movements and graceful gestures at a very early age. He also grows up in an environment that is full of rocking rhythms and melodious airs. From the moment that he makes his first steps, he shows how astonishingly sensitive he is to the slightest appeal made by rhythmical sounds. Such sounds make him move eagerly up and down or from side to side quite spontaneously and wave or beat his hands, smiling contentedly and displaying obvious satisfaction. There are three main ways in which the growing child is surrounded by an environment of rhythmical song, movement and dance in Africa—games, fables and

palavers. Since the structure of the palaver or African conference sums up that of the other two, we shall confine our discussion to that.

The Palaver as a Model of Community Ceremony

At the level of the local community of the village or clan, the so-called palaver in fact takes the place of liturgy. The conferences known as palavers are really plenary assemblies, often with a predominantly legal character and with the emphasis on oratory. Their procedure is highly complex and their aim is not always easy to define. At the same time they frequently resemble fairs and act as an entertainment, a relaxation within the community, an artistic show or an educational and socio-cultural manifestation. The educational aspects in particular make the palaver a kind of summary of the clan's traditional wisdom and everyone takes part in it, as though it were a kind of re-education in ethnical knowledge.

Let us consider, for example, the case of a meeting called to settle a difference between two villages or two clans about landed property. Food and drink are prepared for the occasion and the day of the meeting is arranged. The palaver may last, in fact, for three days, a week or even two weeks. During this time, all ordinary activities cease and the families concerned in the dispute come together. The assembly includes the chiefs, orators, judges, counsellors, witnesses and other members of the families together with a crowd of curious neighbours and their orchestras.

The situation is discussed in detail and, in particular, the whole history of the land in question is retraced, including the various movements of clans and changes in occupation up to the present. Each orator stands and questions the other side in a series of proverbial formulae that evoke a lively response from the others. He then reconstructs the sequence of events step by step. Each stage in the story is concluded with a proverb or a series of proverbs. This conclusion takes the form of lively chant sung by all those present. From time to time, too, the orator, acting as the animator of his community, makes the outline of a dance movement which is at once taken up by those of his own side and developed more fully.[15] Even from this very brief description, then, it can be seen that the orchestra or choir of people, the proverbial sayings, the chanting or singing and the dancing—and, of course, the dress—all play a very important part in the palaver. There are three constitutive elements of active participation on the part of the whole people in the African palaver which could be used with great benefit in the liturgical renewal. These are the dialogue (which has an obvious place in the homily), local rhythmical chanting or singing and the rhythmical movement accompanied by gestures of the dance.

Dancing has a very special function in a shared action carried out by the whole assembly under the guidance of an animator. On the one hand, it

bears witness to the intimacy, intensity and depth of the participants' feelings. On the other hand, it symbolises their contact with the sphere of mystery. This idea can be expressed differently in the following way. Dancing testifies to a special density of feeling that cannot, in the normal course of events, be exteriorised in any other way. The intensity of feeling united vertically with what lies beyond this world has repercussions in the horizontal communion through the fact that it is shared with the community in dancing. The dance therefore marks the summit of communication between beings.

4. THE REPERTORY OF DANCES

There are, of course, many different kinds of dance in Africa. They are not all of the same quality, nor do they all have the same aim. They cannot therefore all be praised without distinction, adopted with equal enthusiasm or condemned without careful consideration. It is worth while looking very briefly here at a few special forms of dance currently practised in Africa. If we are to assess the value of a dance, we must, of course, refer to the context within which it takes place and we shall therefore examine this context first. There are certain circumstances which normally call for dancing as an integral part of the situation.

1. *The Context within which Dancing takes place*

(*a*) Birth, especially of twins, which is regarded as an unusual event, implying an exceptional intervention from on high and seen as a gift of special kindness on the part of the ancestors; it is therefore inevitably connected with the sacred sphere of life and has to be welcomed and indeed 'consecrated' by a special ceremony of dancing.

(*b*) Reception of the mother after childbirth: After spending two or so weeks in 'retreat' after childbirth, the mother 'comes out' into the fresh air and 'shows' the newly-born child to the sun. In districts where there is a high rate of infant mortality, a baby who has overcome the test of the first two weeks of life bears witness to the fact that he is especially favoured by the ancestors. The event is closely connected with the sacred sphere and calls for a ceremony of thanksgiving when new favours are at the same time sought. Dancing forms an essential and necessary part of this ceremony.

(*c*) Initiation rites of many different kinds, of different length and importance, according to the ethnic group, the region and the aim. There can, for example, be rites to initiate people into a trade or an association or to initiate adolescents into adulthood (with or without circumcision). Dancing plays such an important part in these rites that some (see (*d*), (*e*)

and (*f*) under 'Special Dances' below) are employed exclusively in initiation, with the result that to use them in a different context would be regarded as offensive and abnormal. Some dances are learnt, for example, only during the initiation to prepare young men and women for their social, procreative function and consist of simulating, in a way that may sometimes not even be known to the dancers themselves, and by means of ritual gestures which do not have a lewd meaning, but rather point to the games of conjugality. Where life itself is concerned in any of its forms and aspects, dancing is normally involved, because, as Roger Garaudy has pointed out, 'dancing is a way of living' and, where there is feasting, the dance reigns as queen.[16]

(*d*) Other events with a clearly vital and sacred character also take place within the framework of the dance. These include, for example, exorcisms and healings,[17] incantations said or chanted with the aim of curing, marriage, funeral and ceremonies marking the end of mourning and propitiatory or expiatory prayers chanted at the burial ground as well as feasts of enthronement or reconciliation.

A festive or sacred occasion in Africa without dancing is, we may conclude, like a body without life in which there is no communion with the world. To quote Garaudy again, 'dancing is experiencing and expressing with the maximum intensity man's relationship with nature, society, the future and his gods'.[18]

2. *Special Dances*

Because of the great diversity of contexts within which dancing takes place in Africa, there is a very rich and varied repertory of African dances. Apart from the many general dances that are often used for recreation, there are also many special dances that are sometimes set aside for certain persons or functions. In this section and the following one on dances used for recreation and amusement, we shall discuss very briefly some of the main types—

(*a*) The chief's dance: On certain special occasions when a parade takes place, the chief, with a solemn gesture, rocks backwards and forwards, waving the insignia of authority and gently moves his legs.

(*b*) The head dance: In this dance, the head is swayed from right to left and sometimes moved in all directions, either with or without rocking the whole body.

(*c*) The shoulder dance is performed by rocking the shoulders from top to bottom and turning them, sometimes both together and sometimes alternately; this dance is often performed by the chief alone or for him.

(*d*) The belly dance, in which the belly is made to ripple with the navel uncovered.

(*e*) The hip dance is basically a skilful combination of swayings and twistings of the waist and hips.

(*f*) The buttock dance is a quivering, waving motion of the buttocks.[19]

3. *Recreational Dances*

(*g*) The face to face dance: the dancers are in two rows; in a continuous movement backwards and forwards, they come close to each other, facing each other, but without touching each other (in the traditional form of this dance, there is no dancing body to body in pairs); withdrawing together, the dancers gently move their legs and beat their hands together.

(*h*) The ronde: formed up one behind the other, the dancers move around a drummer who animates their dancing, determining the pace and the movement.

(*i*) The solo dance, in which the dancer moves in front of the tom-tom player, swaying and rocking in various esoteric ways.

(*j*) The fray: this is almost a mass dance. Following the rhythm set by the tom-tom, everyone moves in every direction, hopping, twisting and swinging almost at random.

This great range of dance techniques has, in addition to the aim of creating communion with life or living union, several other main purposes: the full exploration of the human body and each of its parts so that it can be used in a controlled way, exercised and freed from inhibitions.

Combining the chief's dance (*a*) and the head dance (*b*) has resulted in an excellent complex of swaying movements in the Mass of the Zairian rite for the procession of entrance, offering and leaving the church and for the incensing of the altar. In the cathedral church of Idiofa in Zaire, the priest-in-charge has succeeded in using the shoulder dance (*c*) very effectively around the altar. In the church of Notre Dame de Kimwenza in Zaire, a little group of girls mime the offering and the creed extremely well.

Dancing has preserved its character as a primordial rite and as a living expression of communion. One small fact is worth mentioning in this context. When Mgr B. Gantin was created a cardinal two years ago, a party was arranged in his honour by the fathers of the African Missionary Society in Rome. Many guests came from many different countries and I was curious to see what the party might have to offer that was distinctively African in style.

Towards the end of the party, a group from Benin City suddenly came together in front of the cardinal, apparently quite spontaneously. One of them made a movement with his shoulders and soon the whole group was dancing with the upper parts of their bodies, a typical African dance. The leader who had initiated the dance was the cardinal's brother and the

dance represented the family's sanction and the ancestral consecration of the event. On the other hand, it also symbolised the exultation of the group, the desire to bring down God's blessing on the cardinal and the honour given to him. It also expressed for him certain wishes, which could be translates as: *Proficiat, vivat ad multos annos.* This dance was a fitting and necessary conclusion to the evening and without it the Africans present would not have felt fulfilled. It was for them the expression of the sacred sphere of life. The African feels in the depths of his being that dancing is a summary of many ways of expressing communion with that sacred sphere. He also feels that it restores to the body its spiritual value of living mediation and universal communion.

5. CONCLUSION

What we have integrated into our liturgy is not one or other category of dance in the form in which it already exists, nor one or other dance that is peculiar to one ethnic group or another. What we have tried to do is to integrate the fundamental value of African dancing, the value or philosophy that does not divide man into two or regard the body as created by the devil or as the prison of the soul, but teaches that it is the place of universal mediation. The dance symbolises for us contact with what lies beyond this life and communion with the cosmos. It also puts an end to the division of man into soul and body and restores harmony to that unity of soul and body in the individual, the unity between the individual and the community and the unity between the material and the spiritual world, all within the one universe. The beauty of the dance reflects the harmony that exists between the one who dies and the one who remains behind and in that way marks the end of all solitude.

In this harmony and rhythm formed by human voices, musical instruments and dancing, the traditional communities of Africa take on a festive air. The festival is an explosion of joy, and upsurge of life and emotion born in man's encounter with his fellow-man. It is the birth of freedom. Even more, man's encounter in Christ with the Quite Other one, his Father, is an even more powerful source of this feeling of festival and freedom. In this sense, then, the Eucharist is the festival *par excellence*. If Christ sets us free, then he must also set free what is valuable in life in the eyes of his Father, the Creator. According to the Fathers of the Church, Christ saves only what he takes up. The African is strengthened and heartened by the integration of what he values in life—his gestures, rituals, rhythms, melodies and symbols—into the liturgy and is anxious to purify his techniques in dancing so that these too can be used.

In the form in which it is accepted in our churches, that is, at our present stage of research and experimentation, dancing consists mainly of

rhythmical, controlled and recollected movements of the whole body (and not simply of one part of the body). These liturgical dances are carried out either by everyone present in the church (during the processions at the entrance, the offering and the leaving after Mass, for example), or by the choir alone (during certain chants or hymns) or by the priest and his assistants (during the incensing). Especially when they are accompanied by graceful gestures, which are symbolic and often stylised,[20] the harmonious swaying of the people and the sound of local musical instruments and full-throated, melodious singing irresistably call to mind the omnipotence of God echoed in the community of his children. It is this life of the Spirit of the Father and the Son, the breath of the community of brothers and sisters, which gives the liturgy of Africa its air of festivity and true celebration, in which the human environment is a reflection of the divine environment and indeed of the heart of the Father, in whom all his sons are brothers. It is right for our bodies to move in dancing rhythms!

In the future, when there is an original African theology, it will perhaps be called a theology of 'inculturation', because it will have been preceded by this festive liturgy in which a living communion with the love of the Father, the Son and the Holy Spirit—the living God made flesh—is celebrated by the bodily expression of the dance.

Translated by David Smith

Notes

1. My article is based mainly on my experience in Cameroon and especially in Zaire. Despite the heterogeneity of its populations, there is, however, a fundamental cultural unity in Black Africa. See, for example, C. A. Diop *L'Unité culturelle de l'Afrique Noire* (Presses Africaines 1959) p. 7.

2. J. Daniélou *Le Mystère du salut des nations* (Paris) p. 55.

3. Constitution on the Liturgy *Sacrosanctum Concilium* 30 and 38.

4. A. Abega 'Ndzon-melen, Une expérience liturgique' *Telema* 4 (1978) 41-50; 1 (1978) 69-70; Sambu Mbinda 'Kiezila ki Khieza' *Telema* 4 (1976) 27-29; see also *Telema* 2 (1978) 91.

5. See the other questions pointed out by A. Abega and Sambu Mbinda in the articles cited in the previous note.

6. See other comments by A. Abega and Sambu Mbinda in the same articles.

7. Constitution on the Liturgy, 48.

8. *Ibid.,* 14.

9. The word 'restoration' and related words occur twenty times and 'participation' occurs thirty times in the Constitution on the Liturgy.

10. One has to be wary of the use of the word 'participation' in the sense in which it is employed by L. Lévy-Bruhl, tied as it was to his theory of prelogism; see *Les Fonctions mentales dans les sociétés inférieures* (Paris 1910). This was in any case later withdrawn by the author; see *Carnets* (Paris 1949) pp. 60, 73.

11. Presses Africaines 1948 and 1962 respectively. See also H. Maurier *Philosophie de l'Afrique Noire* (Anthropos 1976); F. Boulaga Eboussi *La Crise du Muntu* (Presses Africaines 1977); D. Nothomb *Un Humanisme africain* (Lumen Vitae 1965).

12. *Documentation Catholique* (November 1967) 1505 Col. 1941-1943.

13. See certain other approaches to the concept of 'muntu': J. Hahn, *Muntu* (Paris 1958) pp. 110-116; A. Kagame *La Philosophie banturwandaise de l'être* (Brussels 1956) p. 267; P. Tempels *La Philosophie bantoue* (Presses Africaines 1948) p. 28.

14. Boka di Mpasi Londi 'A propos des religions populaires d'Afrique sub-saharienne' *Telema* 2 (1979) 23-24.

15. The interruptions made in the story by the proverbs, questions, chants and dances break the monotony of the proceedings and make it easier for those present to absorb what is going on, with the result that the sessions can continue for a much longer period. The Zairian Mass modelled on this structure lasts for two and a half hours and no one finds it tiring—not even children and old people.

16. R. Garaudy *Danser sa vie* (Paris 1973) p 13.

17. See the formulae described by M. Hebga *Croyance et guérison* (Yaoundé 1973) pp. 9, 21; E. de Rosny *Ndimsi* (Yaoundé 1974) pp. 242-243ff.

18. R. Garaudy *Danser sa vie* p. 14.

19. Other types of dance can also be added to this list—the war dance, for example. If they are interpreted outside their original context and the philosophical framework and ethical structure within which they have developed, these dances can easily be incorrectly assessed and disparaged. They have above all to be judged within their own objective context.

20. Everybody seems to be caught up in the effort to invent new gestures, even in convents of sisters. See for example 'Expression corporelle et parole de Dieu' *Telema* 2 (1976) 29-34.

PART II

Bulletins

Cyrille Vogel

Symbols in Christian Worship: Food and Drink

SYMBOLS—means of recognition and signifiants[1] attempt to give tangible form to that which in intangible. In this sense, all human activity is symbolic: gestures, words, language, social interaction, theological debate, liturgical celebration. More specifically, the liturgical symbol can be analysed as follows:

1. It is necessary to assume a common ground of knowledge and understanding. This implies the existence of a group of initiates; otherwise particular gestures and utterances would be incomprehensible. Some familiarity with an object or event is necessary for any act of recognition; we see this at Emmaus (Luke 24:35: '. . . they recognised him in the breaking of the bread.'

2. There is no room for the arbitrary: the symbol must be understood by all the members of the community and accepted on these terms. Otherwise, gestures and utterances would become meaningless.

3. The tension and polarity between the signifiant and the referent must be kept constant. Should the one be identified with the other in any way, the result would be a 'reification' or recourse to an act of magic. The *Verona Fragments* provide an example: 'gratias agat panem quidem in *exemplum*, quod dicit graecus antitypum, corporis Christi; calicem vino mixtum propter antitypum, quod dicit graecus *similitudinem*, sanguinis quod effusum est.' Destruction of the symbol would amount to the creation of an idol. Conversely, neither the choice of signifiants and symbols, nor their possible modification (bread, wine, rice and the breaking and consumption of the same), will affect the referent in any way. Thus, Thomas Aquinas, in the hymn *Lauda Sion,* states: 'Nulla rei fit

67

scissura/*Signi* tantum fit fractura/Qua nec status nec statura/*Signati* minuitur.'

The gestures and utterances which constitute the act of worship *represent* the intangible, they do not define it merely in terms of concepts and images; they have the effect of making the intangible present and indeed of anticipating it, thereby ensuring a level of understanding which is more profound and more direct than that afforded in ordinary speech; this is especially true of the Eastern liturgy.

1. SACRED FOODS

The types of food and drink which Christians have held sacred are very few in number, showing little variety; meat and vegetables have never been included amongst them.[2]

1. *Bread, wine and water*

These three elements are variously presented:

(*a*) As a trinomial: bread, wine and water. This is attested by Justin Martyr, *1 Apol. 65*: 'Finally, (at the baptismal eucharist), bread, a cup of diluted wine and a cup of water are brought to the president. ... Those ministers whom we call deacons distribute the consecrated bread, wine and water to all those present.'

(*b*) As a binomial (first combination): bread and wine. These two elements figure in the so-called institution narratives (or Last Supper narratives) and vary in presentation:

 (i) According to Mark 14:22-25 and Matt. 26:26-29, the rites of the bread and the cup, juxtaposed directly with no time lapse between the two, take place during a full meal (it is not clear whether at the beginning, in the middle, or at the end).

 (ii) According to 1 Cor. 11:23-26, the rite of the bread takes place at the beginning of the meal, whereas that of the cup is at the end.

(iii) According to Luke 22:17-19a, the rite of the cup and that of the bread (in that order, with the cup preceding) take place before the full meal.[3]

There is no longer any room for discussion as regards the origin of the two rights: Jesus availed himself of the Jewish Kiddusch at the time of the last supper (whether or not we consider this latter to have been paschal).

(*c*) As a binomial (second combination): bread and water. In certain places, for various reasons, the wine was replaced by a cup of water. In connection with this, see Cyprian *Epistle 63 to Caecilius of Biltha* (relating to the Aquarian controversy).[4]

(*d*) In singular form:

(i) The cup alone: the obvious alterations in the narrative of the institution given in Luke 22:17-20 do not destroy the hypothesis that the Eucharist might have been celebrated with the cup alone.

(ii) The bread alone: there are many texts documenting the celebration of the Eucharist with bread alone, in the form of *fractio panis*.[5] Thus: Luke 24:30-35; Acts 2:42, 46; Acts 20:7 (Troas); Acts 27:35 (the storm); 1 Cor. 10:17. The second Eucharistic narrative in the *Didache* gives only the breaking of bread at the dominical Eucharist. *Didache* XIV, 1: 'When you come together on the Lord's Day, break bread and give thanks'.

In addition to the documentation of the official Church, it is useful to look at evidence from dissenting congregations: the *Acta Thomae* cc. 27, 29, 46, 48 (Lipsius-Bonnet *AAA* II, 2 pp. 143, 146, 164) and the *Acta Iohannis* cc. 109, 110 (Lipsius-Bonnet *AAA* II, 1 p. 207).

2. *Milk and dairy products*

Milk and dairy products are consumed either separately or in conjunction with bread or honey (or water); this was the case for the Artotyrites: *Passio Perpetuae et Felicitatis* c. 4.[6] Milk mixed with honey and water forms part of the baptismal Eucharist, together with the binomial of bread and wine. The *Hauler Fragments* give clear evidence of this.[7]

3. *Oil or olives*

Oil or olives are consumed either separately or in conjunction with the consecrated bread and wine, or even with cheese. The *Hauler Fragments* do not distinguish between the blessing of the bread and the wine on the one hand, and that of the oil, the olives and the cheese on the other.[8]

4. *Salt (sacramentum salis)*

Salt has never, strictly speaking, formed part of a sacred meal. As far as we can tell, it was used in the rite of baptism as a symbol of fidelity and protection, but not as a theophagous symbol.

5. *Obscene foods*

Let us also mention those obscene foods (*sperma, menstruum*) used in certain Gnostic groups; information about these is given in the *Pistis Sophia* p. 147 and by Epiphanius *Haer* 26, for example.

6. *Fish*

In pre-Christian cultures, fish had long been eaten as a sacred food. In the ancient world, it was a symbol of virile strength (*ichthyphalles*);[9] in Judaism, it heralds the messianic age. Christians took it up for its

eschatological significance. In the context of a meal, fish does appear in singular form, but most frequently in a trinomial (bread, fish and cup).

2. SACRED MEALS

Sacred food is tantamount to a sacred meal, yet it is nevertheless necessary for us to define our terms. A sacred meal is one which, by the intermediary of ingested food and drink, brings those who participate in it into a relationship with the divinity; in the act of eating, the participants communicate with the divinity. Therefore, the sacred meal aspires to theophagy, with a view to union with the deity or to participation in the divine life (usually bliss in the after-life). Thus:

1. The sacred meal is not merely an oblation of gifts to the deity, in honour of whom they will be eaten. Due to the existence of a symbolic relationship between the gift and the god, oblation merges with immolation (the suffering and dying god) and consumption: *ipse offerens, ipse et oblatus* [or *oblatio*].

2. The sacred meal differs from, indeed, is set in opposition to an ordinary full meal. It is always a 'stylised' meal, which never becomes identified with a meal eaten to appease hunger, even if the sacred act takes place in the context of an ordinary feast.

3. The sacred meal is not merely a dinner, even one set in a context of prayer or within a religious framework, such as the monastic meal, *agape* or caritative meal.

4. The sacred meal must be consumed in the place of consecration, the items of food and drink may not be taken from the place of worship (whether it be a private house or a building specifically intended for worship). This we find in Graeco-Roman religions: Cato *De Agricultura* 83: *Ubi res divina facta erit, statim ibi consummito*; *CIL* VI, 1 p. 576: *Extra hoc limen aliquid de sacro Silvani [temple of Silvanus] effere fas non est*.

Similar examples within Judaism can be found in: (Passover) Exod. 12:10; Num. 9:12; Deut. 16:14; (outside the Passover) Exod. 24:31-34; Lev. 7:9, 19; Num. 18:10; Lev. 22:30; 24:9,[10] and within Christianity: Innocent I *Letter to Decentius of Gubbio* (416): 'Nec longe portanda sunt sacramenta [here the *fermentum*, that is, a fragment of the consecrated bread]'.

5. The sacred meal is eaten in secret, that is, amongst initiates alone, excluding outsiders, thereby creating a privileged bond between those eating together.

3. PRIMARY EUCHARIST

The term 'primary Eucharist' is used here to designate any sacred meal where the sign or signifiant (bread, wine, water; either alone or in combination) is placed in a direct relationship with the body and blood of Christ as referents. As early as the middle of the second century, bread and wine established themselves as the dominant elements, and remain to the present day in the celebration of the Eucharist, the only sacred meal still current in Christian worship (in Eastern and Western churches and post-Reformation churches).

4. MEALS INCLUDING FISH

1. The narratives dealing with the institution of meals including fish (bread and fish) are:

(a) The feeding of the five thousand with bread and fish. (Mark 6:30-44; Matt. 14:13-21; Luke 9:10-17).

(b) The feeding of the four thousand with bread and fish. (Mark 8:1-10; Matt. 15:32-39).

Let us take Mark 6:39-44 as an example: 'Then he commanded them all to sit down by companies upon the green grass. And taking the five *loaves* and the two *fish* he looked up to heaven, and *blessed,* and *broke* the loaves and *gave* them to the disciples to set out before the people; and he *divided* the two *fish* among them all. And they all ate and were satisfied. And they took up twelve baskets full of broken pieces and of the fish.'

2. Other New Testament accounts apart from the institutionary narratives (bread, fish, honey).

(a) The appearance of Christ at Jersualem after the resurrection, recounted at the end of Luke, chapter 24:41-43: 'And while they disbelieved for joy, and wondered, he said to them, "Have you anything to eat?" They gave him a piece of broiled fish and a honeycomb. And he took it, and ate before them.'[11]

(b) The appearance of Christ on the shore of lake Tiberias, according to the appendix to John's Gospel, chapter 21:9-13: 'When they got out on land, they saw a charcoal fire there, with fish lying on it, and bread. Jesus said to them, "Bring some of the fish that you have just caught." . . . Jesus said to them, "Come and have breakfast." Now none of the disciples dared to ask him, "Who are you?" They knew it was the Lord. Jesus came and took the bread and gave it to them, and so with the fish.' Such sacred meals with fish are not recorded after the third century. They did survive beyond that date in the form of a funerary meal (*refrigerium*), including, it seems, the eating of fish (because of the eschatological significance of the

F

Ichthys). The funerary feast is always held directly beside the tomb, the deceased is assumed to be present (a votive *cathedra* is reserved for him) and to experience some comfort in the precariousness of his existence in the after-life.[12] As no relationship is established between the fish (plus bread and cup) and the body and blood of Christ, the *Ichthys* meal does not constitute primary Eucharist.

Translated by Christine Halek

Notes

1. The French original of this article employs the words *signifiant* and *signifié*, linguistic terms introduced by Ferdinand de Saussure. Although the obvious grammatical and semantic relationship between these words can be brought out in the Romance languages without any difficulty (as in Latin *signum—signatum*), this is not possible in the context of the Germanic languages. It has therefore been decided to translate them here using the corresponding linguistic terms current in English, that is, as 'signifiant' (a direct borrowing) and 'referent' respectively. (Translator's note.)

2. There is an extensive bibliography relating to food and sacred meals in Christianity. In order to avoid overburdening this article, we would refer the reader for a *status quaestionis* to C. Vogel *Symboles cultuels chrétiens. Les aliments sacrés: Poisson et refrigeria (banquets funéraires chrétiens* (Spoleto 1976) pp. 197-265.

3. Luke 22:17-20 is open to a three-fold interpretation justified, in each case, by the manuscript tradition: (*a*) Luke 22:17-19a (the version given above in the text of the article); (*b*) Luke 22:17-20: the first cup and the bread *before* the full meal; the second cup *after* the meal, that is, a sacred meal with two cups; (*c*) Luke 22:19b-20: a single cup at the end of the main meal.

4. For information relating to the Aquarians, see Filastrius *Haer.* 96; to the Ebionites, see Irenaeus *Haer.* V:1:3; to the Marcionites, see Epiphanius *Haer.* 42:3; to Tatian, see Epiphanius *Haer.* 46:3; to the Encratites, see Clement of Alexandria *Paed.* 3:2:32; *Strom* I:19:96; to the Judeo-Christian Gnostics, see Epiphanius *Haer.* 30:16; to the Apotactics, see Epiphanius *Haer.* 61:1; *Martyrium Pionii* 3 (sanctum panem et aquam degustare); see also the *Actus Petri cum Simone* 2 and the *Acta Thomae* 158 and 126. See G. Gentz 'Aquarii' in *Reallexicon für Antike und Christentum* (1950) I pp. 574-575.

5. A. Harnack 'Brod und Wasser' in *Texte und Untersuchungen* (Leipzig 1891) VIII p. 2; A. Schweiwiler 'Die Elemente der Eucharistie' *Forschungen zur christlichen Literatur und Dogmengeschichte* III: 4 (Mainz 1903); H. Lietzmann *Messe und Herrenmahl* (Bonn 1926). (The existence of a *fractio panis* without any cup whatever is independent of the theological conclusion which the author believes may be consequent upon it.)

6. *Passio Perpetuae et Felicitatis* 4: 'I saw [the vision of Perpetua] a large garden in the centre of which a tall, white-haired man was seated, dressed in shepherd's clothing, milking his ewes; around him were thousands of men dressed in white. Lifting his head, the man saw me and said, "Welcome, my child". He called me to him and he gave me a mouthful of the milk [dairy produce]. I took it in my clasped hands and I ate it [*sic.*]. All those present said "Amen". I woke up whilst still eating something indescribably sweet and soft.'

7. The *Hauler Fragments* (Latin version of the *Apostolic Tradition*) (Tidner p. 131): 'Frangens autem *panem* singulas partes porrigens dicat: Panis caelestis in Christo Iesu. Qui autem accipit respondeat: Amen. Praesbyteri vero si non fuerint sufficientes, teneant calices et diacones . . . primus qui tenet aquam, secundus qui *lac,* tertius qui *vinum.* Et gustent qui percipient de singulis . . .' The baptismal Eucharist involves five consecrated elements: bread, wine, water, and milk and honey mixed together.

8. The *Hauler Fragments* (Tidner p. 127): 'Si quis oleum offert, secundum panis oblationem et vini [in the episcopal Eucharist] et non ad sermonem sed *simili virtute* gratias referat . . . Similiter si quis caseum et olivas offeret . . .'

9. We reproduce the author's thought and word, but there seems to be a confusion. Both the *Shorter Oxford English Dictionary* and Jung himself in *Memories, Dreams, Reflections* (London 1963) know only *Ithyphallus,* not *Ichthyphalles,* i.e., *ithus,* erect, rather than *ichthus,* fish. (Editor's note.)

10. Exod. 12:9-10: 'Do not eat any of it raw or boiled with water, but roasted, its head with its legs and its inner parts. And you shall let none of it remain until the morning, anything that remains until the morning you shall burn.' Exod. 29:34: 'And if any of the flesh for the ordination, or of the bread, remain until the morning, then you shall burn the remainder with fire; it shall not be eaten, because it is holy.'

11. The accuracy of the reading 'honeycomb' which has disappeared in certain modern translations is excellently attested; see Nestlé (in a note) and H. J. Vogels *Novum Testamentum graece* (in the Greek text). The reading is retained in all the Latin translations. It is known that honey is an important element in Jewish funerary feasts and ritual usages.

12. Basic documentation relating to Christian funerary feasts is given by F. J. Dölger (1922), Th. Klauser (1928), A. M. Schneider (1928), A. Parrot (1937), A. Stuiber (1957), F. Cumont (1949), R. Marichal (1962), J. Doignon (1969) and J. Engemann (1969). It is impossible within the limits of a short article to enumerate the literary, epigraphical and iconographical material relating to the subject and the work which these have occasioned. We attempt to give an account of the state of the question in C. Vogel *Symboles cultuels chrétiens. Les aliments sacrés* (the work cited in note 2) pp. 233-247; *Le Repas sacré au poisson chez les chrétiens* (Paris 1970) pp. 83-116; *Le Banquet funéraire paléochrétiens, une fête du défunt et des survivants* (Paris 1976) pp. 61-78; *L'Environnement cultuel du défunt durant la période paléochrétienne* (Rome 1975) pp. 381-413.

Jean-Pierre Jossua

Unofficial Eucharistic Prayers: An Appraisal

I HAVE been asked to produce some aesthetic evaluation of modern public prayer. For more than a decade this production of non-official public prayer has flourished in the field of what the new missal calls 'the Eucharistic prayer' and used to be called the 'canon of the Mass', and so I thought it best to limit myself to this field.

But when one has to produce an aesthetic criticism of an artistic creation which is meant to express the belief which Christians incorporate in their prayer, it is impossible to dissociate the aesthetic aspect from the theological one. In this case, indeed, it is not simply a matter of producing a more or less successful verbal composition as a garland with which to decorate some thought or prayer which could equally well do without this. It is much more a matter of creating something which expresses both the religious content and its beauty, and therefore of finding the best possible words to convey what is crying out to be conveyed to God or to one's fellow men. Any judgment of such a text must therefore take the composition as a whole. We have to consider not only the aesthetic quality of the text but also the question whether it can take up, and at the same time renew, a traditional religious experience which is already structured and, lastly, where the liturgy is concerned, the question whether such a prayer lends itself easily to actual use by the Christian community. It may well be that a text which is thought to have this kind of evocative power may one day be used for other purposes by other readers and at other times: how many 'sacred' words do we not use today in a purely 'secular' way? Nevertheless, since the text is meant for us as Christians and we have to consider its value, we have to judge its aesthetic quality according to whether it helps us to develop and revive our own prayer.[1]

1. WHAT HAS LED TO THE DEVELOPMENT OF UNOFFICIAL EUCHARISTIC PRAYERS?

I have no intention of analysing here the clerical power-system which has led the supreme authority to reserve jealously to itself the right to approve any Eucharistic prayer and to reject others. Nor am I here concerned with the 'safety-first' obsession which is supposed to justify this attitude. This obsession seems to go hand in hand with an evident Malthusianism: Christian folk cannot be associated with establishing what should be the very core of their prayer. Here I only want to indicate the reasons why people are no longer happy with the official or approved canons which, in spite of repeated prohibitions, have led to the creation of other canons, once the taboo of having only one canon in one sacred language had been broken.[2]

The first weakness of the official canons is their anachronistic and hieratic language, the cultural distance of which has become para-doxically obvious in our living languages. This defect has become even more obvious, especially in the prefaces, by the emphasis and a certain triumphalism which derive particularly from the misuse of texts taken from the Old Testament. This cultural shift not only prevents believers from praying in a language with which they are familiar and in which they have expressed their experience as Christians and as human beings since their childhood, but also from developing the poetic potential of their language. These texts, imprisoned in the style and liturgical language used by the Fathers, led to formulae in which people can see neither the meaning they could have for them nor the faith which they were supposed to express, just as they do not leave any room for the imagination they were supposed to inspire.[3]

To 'pray that your angel may take this sacrifice to your altar in heaven' (Eucharistic Prayer I); to say that 'He (Christ) opened his arms on the cross to put an end to death' (II); to call to people's minds the 'countless hosts of angels that stand before God to do his will, look upon God's splendour and praise him day and night' (IV); to call the Spirit 'God's first gift to those who believe' (IV); to ask God to give us the body of Christ 'so that we may become good Christians' and 'to let the dead be close to him in heaven' (Germany, in a liturgy for children); to make schoolboys say 'we offer you the holy victim' (Switzerland), and, to finish this litany, to strike up a powerful and exciting hymn with 'The towns and the coun-tryside, ordinary people and those in power, the living and the dead already sense your presence and cry out to you' (Holland)—all this is using a large amount of imposing words to convey very little to people today.

There is no room to deal with the scruples which beset a number of

ordained or lay celebrants as a result of using certain theological formulae that are hardly convincing,[4]—this simply helps to weaken the authority with which the present forms of the Eucharistic Prayer have been invested.

There is a much more serious problem which has to be tackled, and this is that formally fixed formulae of prayer seem to be incapable of connecting with people's actual life. Christian worship, which implies the total spiritual dedication of a person's life and which at the same time is supposed to be the force leading to conversion and to an increasingly meaningful life, makes no sense if it does lose contact with life as it is. How can those petrified, antiquated and never varying texts possibly express and produce a relevant and committed faith in this or that community or situation?

Only people who know little of the tradition of the Eucharist will object that this is not what the canon is supposed to do, but rather the business of general prayer or the sermon. These canons are in perfect harmony with the anonymous, passive, and wholly uncommitted character of our typical parochial gatherings. So, why should we be astonished that there actually are some committed Christian communities which are determined to integrate their prayer and interpersonal communion with their actual existence and their witness, and because of this want to make their Eucharistic prayer fit in with their need? Hence the creation of their own Eucharistic prayers.

Here we are touching the heart of the matter. The main weakness of the Christian liturgy does not lie so much in its anachronism or its abstract nature—these things can be remedied. It is much more its rigid uniformity of meaning and expression. Every particular event demands its own way of celebrating. There are parish masses, Eucharistic celebrations for groups of young people, Eucharists celebrated at home, Eucharists celebrated for vast gatherings, Eucharists for annual or exceptional festivities. It should be possible to reconcile the need for reliable texts which safeguard a given tradition with the need to build up a Eucharistic prayer composed by and for our present contemporaries in a way which is both more beautiful and closer to their personal existence. It should not be too difficult to reassure those who need objectivity and security, and at the same time to allow others, sensible enough to accept advice and to be discerning, the freedom to compose Eucharistic prayers their own way. In any case people are beginning to do exactly that—but unfortunately sometimes in a way which rejects all norms and is often not very responsible. In actual fact, people are creating their own canons of the Mass, whether we like it or not, and they are doing it all over the place.

But, do they really achieve what they are crying out for, aesthetically, theologically, liturgically, and existentially? That is the issue.

2. WHY DO THE COLLECTIONS OF FREELY COMPOSED CANONS FAIL TO SATISFY?

Most of the freely composed texts that go the rounds inevitably pro-
voke severe criticism when a reader is wholly ignorant of the cir-
cumstances which produced them. It would be wrong, in my opinion, to
extend this criticism to the liturgical event from which they originated.
But while backward-looking ecclesiastical reactions lack a sense of
perspective, the spread of freely composed canons very often lacks a
sense of proportion or is the result of satisfying some childish need. As a
result the reader is liable to see in them only the glibness, the clumsiness,
the theological weakness and the literary mediocrity of a prayer which, at
a given time and in a given gathering, may well have conveyed exactly and
even felicitously the life they lived and the celebration of their most
profound religious conviction.

So the first thing I would like to say is that we must very carefully
distinguish in most cases between liturgical effectiveness and aesthetic
value discernible by hindsight. So we should discourage the spread of new
canons, particularly since printing adds significantly to the weight of
'careful research' already attributed freely to its productions by a Church
now addicted to duplicating. At the same time one would like to suggest
that people do not judge what such a text meant actually on the occasion
for which it was composed, simply by *reading* the text: it would deprive it
of its context.

There are two collections of canons which were indeed worth pub-
lishing[5] and deserve looking at more closely.

The first has the title: *A la recherche de prières eucharistiques pour
notre tems* (*Coll. Vivante Liturgie*, 90, Paris 1977). It comes from the
abbey of St Andrew (Bruges) and shows great luturgical maturity. As
one reads these canons one feels that all of them achieve a high
level of authenticity and some of them (e.g., VIII and XXI) are quite
remarkable. They presuppose a high degree of culture—particu-
larly religious culture—among the participants, but, granted that
feature, these participants must have found them well within their
reach.

There are, however, a few flaws which are rather obvious. For instance,
in places where the people are expected to join in, the texts are too
complicated and literary to lend themselves to being spoken in chorus.
The introduction of a new canon in the Eucharist presupposes either that
there is only one celebrant (in any case, the claim, whether clerical or lay,
to 'recite the whole lot' makes no liturgical sense at all) or that there are
parts in the text which are easy to speak by the whole congregation. To
reserve the canon exclusively to the ordained ministers is in no way
demanded by theology as is sometimes maintained: the whole con-

gregation is sacramentally active—though this does not mean that they have to assert this all the way through.

Another drawback is the frequent use of the Syrian canon. Because this canon recapitulates the thanksgiving, it has the advantage of enabling the narrative of the institution to be inserted into the flow of the evocation of benefits and thus avoids the usual abrupt introduction of the narrative without having to suppress the Sanctus. But this leads to Eucharistic prayers which put considerable strain on our modern patience. This is particularly true when the author is a great liturgist, such as H. Dufrasne, but not a great poet.

This leads to another weakness in this collection: the literary quality is of an unfortunately low calibre. The images and similes are sometimes awkward ('may this space of depth and communion/take shape in silence', I), often trite ('life has run out like a handful of sand', II, or 'the bread of hard work/the wine of our timid joys', VII, or 'looking at the growing grass or the blue sky', XIV), and sometimes as antiquated as those used in our official canons ('You gather us in the light of the luminary bodies/under the heavenly tent which your hands have erected', V).

The real problem, however, lies elsewhere. Practically none of these prayers can be used for another group without appearing rather phoney. The only way of understanding the themes and the vocabulary which are rather enigmatic is to put them back in their context, and this, fortunately, is made possible by the detailed explanations which accompany these canons. For instance, canon I originated in a cultured religious seminar after doing a great deal of work in groups on the Jewis roots of Christian prayers; canon II was worked out by a group of persons who were going through a very difficult phase in their life, but all were fairly well acquainted with the Bible; canon XII came from a semi-parochial community which had been discussing their social responsibilities.

The second lesson to learn from this study is therefore that even a high-quality collection is not easy to make use of in other circumstances.

Frankly, I do not even see how such a collection would be educationally useful for those who would like to make up their own canons, except for the critical observations which, as far as I know, only this collection provides. The reader may draw his own conclusions on this after reading about the collection Saint-Bernard.

This collection bears the horrible title: *L'Ombre du silence* ('The Shadow of the Silence', Paris 1977) and has been edited by members of the Saint-Bernard community. In a somewhat pretentious and rather fumbling way it tries to play on two registers at one and the same time and contains not only canons but also religious poems and prayers which can be used privately.

From the strictly literary point of view it is far more effective than the

. Belgian collection but often moves considerably away from the Eucharistic tradition. In general, it reveals a fine and profound religious intuition which is sustained throughout the canon. On the other hand, the text is much more difficult to grasp since the composition comes close to modern poetry and so the language is rather less articulate, more disjointed. Must all serious attempts at renewing the language of religion necessarily be as esoteric as modern poetry?

These canons, then, are certainly more evocative, but this evocative quality implies a cultured public in a somewhat exclusive context, and this makes them once again difficult to use outside their context. And while there are some texts (e.g., 9 and 54) which stand out for their simplicity, they are at the same time rather trite. Some others are wholly centred on one passage of the gospel, such as the parable of the seed (28), and could therefore well be used in a congregation or group which has been meditating on this passage, but then again, is it wise to compose a whole canon on such a clearly dominant theme?

Then there is the theological criticism which such publications have to face when they present themselves as models. At its root every Eucharistic tradition must contain a number of basic values: the proclamation of the word, the commemoration of Jesus Christ, thanksgiving, the offering of oneself in the faith, the communion with Christ and one's fellow believers in the meal, the belief in the action of the Spirit, and so on. A theologian will assess liturgical publications according to the presence of these values in the texts before him. From this point of view a very large number of the canons are found wanting. Here the French collection has no doubt achieved a higher standard than many others, particularly where the offering and the epiclesis are concerned.

Should one blame those collections for this? The answer will be 'yes' if one judges them as models for repeated celebrations. But can one maintain that everything must be mentioned explicitly in every single canon? If a creative group maintains an on-going renewal, surely, the whole of the Eucharistic tradition will find itself expressed in the whole of the group's productions? Is it then, once again, a matter of publishing or not? The problem seems to be rather one of freezing something that makes sense only as one moment in the flow of a common search or that met the needs of an extreme situation which it would be absurd to think of as representative.

So the third lesson we ought to draw from this investigation is that it would be wrong to want to turn the result of some hesitant research or something which fitted a particular occasion into an inscription on marble. A celebration is but one act, and therefore transitory—and by the same token not really dangerous. Some other time, in some other place, one produces something else, and bit by bit we shall come closer to the

ideal of a liturgy which is perfectly traditional and perfectly significant in its actual performance. . . .

Should we record and publish an improvised liturgy? My own opinion is that these freely composed canons should be taken as improvisations put down on paper beforehand in order to bolster psychological confidence—just as one writes down a sermon—but not as liturgical productions meant for regular use. They only replace the kind of improvisation which the early Christians practised and the re-birth of which would meet our present needs. They would take the same chances as any lyrical or epic creation which becomes a success.

3. HOW CAN WE ENCOURAGE AN IMPROVISATION WHICH IS BOTH BEAUTIFUL AND RESPONSIBLE?

If the composition of canons is prohibited, the very idea of improvising one must produce a real sense of horror in some church authorities. Moreover, the whole training of the clergy points in the opposite direction and makes them incapable of improvising in any way whatever. So they are not merely inhibited but will be legitimately afraid of the danger to which they might expose the liturgical heritage which is entrusted to us. This danger, in fact, exists because people have had so little training (leaving aside the whole matter of gifts) in improvisation that the theological lacunae and the feeble aesthetic sense of so many canons are nothing compared with those that beset most of the rare improvisations which it has been my luck to witness.

Now, this situation is in total contrast to the improvisation, which was universally practised, as we know, in the old liturgical tradition, slowed down afterwards, and practically disappeared completely in the fifth century. This was the result of the over-sacralisation of communion and the lowering of the quality of those who presided over the Eucharist. But the decisive factor doubtless was the prevailing mentality of fighting heresies and saving the confession of faith which was embodied in the canon.

It is important, however, to remember that this improvisation was not inspired by some 'enthusiasm' or the urge to create something totally new every time with regard to a canon which is attested as 'traditional' in the New Testament from the beginning and by the underlying influence of the liturgical Jewish heritage. We are ill-informed about how this guided improvisation proceeded. Perhaps we would not be too far out if we imagined a definite framework which had to be filled in, an accepted and extending canvas, and an alternation of literally fixed prayers and improvised ones. Without wanting to bring back a far-off past, it is not hard to understand that a practice which was universal at some time may well be

legitimate. We should also realise that not everything in a liturgical tradition is of the same importance. The renewal brought about by the Council showed this, but only in rather belated measures.[6] Thus disappeared an absolutism which led to attributing equal value to everything passed on by history. Consequently, either it is sacrilege to touch anything whatever, or the 'transgressors' do not know where to stop.

It is true that a Eucharistic tradition comprises a certain amount of basic and precious elements which were listed above and described as *values*. These constitute its real foundation, indispensable for the authenticity of the celebration as well as for the faith of the Church which they express and engender.

This tradition also comprises a certain amount of time-honoured *forms* which vary as varying traditions spring from the old root. These forms express the 'values' mentioned in the preceding paragraph in particular rites: prayers, prefaces (thanksgiving), canons consisting of such parts as an epiclesis, an anamnesis, doxologies, intercessory prayers, etc.

Finally, everyone of these traditions goes through a linguistic experience born of the test of practice, and in this way produces a liturgical *language*, a transmission of texts, formulae and specific, meaningful gestures. It should be obvious that such varying ingredients cannot all be treated in the same way when it comes to the question what should be integrally transmitted and what can be handled more freely and therefore lend itself to some measure of improvisation.

I have frequently improvised myself, but not until I had gradually been introduced to this phenomenon, had seen the remarkable effect on the congregation as a help to the understanding of the richness of a traditional prayer and as a way of making people feel the poetic flavour which simple words can have when they are carefully adapted to the group and the situation. And so I am convinced that one not only can, but must improvise to bring the liturgy to life.

What is absolutely required is to do this only according to what the congregation can really take and according to the degree in which they have assimilated the tradition. In one case one will add or change some words or gestures to help people to accept traditionally given prayers in a personal way, with understanding, and so that these prayers become actually relevant. In another context one improvises on the basis of the whole body of inherited forms, in the manner of one or other of the great traditions. Finally, one or other community may well be sufficiently mature to re-structure completely the whole celebration for some particular occasion, and so to give new life to the basic values which are the substance of the Eucharistic heritage.

It would seem obvious that the diffusion of this sort of liturgical initiative requires some appropriate training. It is only by trying out

improvisation very gradually (in the way in which one learns to preach and not in the way in which one is initiated into the exact reproduction of what the rubrics say), by accepting criticism, and even by undertaking, with others, a strenuous analysis of what one is doing from the point of view of theology, liturgy and the aesthetic rendering of it all, that we may turn improvisation into an opportunity instead of a catastrophe where the life of prayer of our communities is concerned. The availability of the tape-recorder nowadays should make this critical study easier than the practice of being able and having to submit beforehand the texts of the canons which have been made up. In any case, only some initial training is not enough. If the present circulation of freely composed canons does not prepare people for improvisation any better than the official monopoly, how could we help those who, in the spirit of the ancient tradition, would like to have a go at it? At present I can only make one suggestion. This is to produce clear schemes which would set out a twofold sequence of (*a*) liturgical forms and (*b*) of the themes contained in those forms, linked either with the annual liturgical cycle or with particular situations.

There remains a last point. When does a prayer strike us as beautiful and evocative? It would seem to me that a word will find an echo within us if it springs from a genuine human experience. It will touch some serious facet of our human experience, some real sharing in the life of the community, and will be recognised as something truly derived from spiritual experience. Its effect will no doubt be more powerful according to the simplicity of its expression: so-called 'poetic' clichés are useless. Let him or her who is gifted this way have the chance of really creating something, something that rings true. But any word which is personal and really meaningful will also be beautiful if it bears the mark of modesty. On the other hand, words blazing with poetic genius will only be useful in the liturgy if they fit in with the reality of the situation.

It is impossible to produce something that could serve as example in this area of improvisation. And so, to conclude, I refer to an exceptional collection of Eucharistic prayers, namely, that of Huub Oosterhuis.[7] In spite of one or two weak points, its theology is sound. A fair number of these canons manages to be actually relevant and usable in other circumstances, modern without being esoteric or affected, and often genuinely beautiful and moving. This may have been the fruit of a powerful Christian experience which has integrated the confused and complex human experience with that sense of respect and infinite distance which should mark any approach to God. This success may also be due—and this is the marvel of creative art—to the fact that the words are genuinely poetic and so can catch the simple beauty of everyday life in words, the loving search of a heart looking for God, and the vibrant hope of a people that cannot do without God. So it would seem to be possible to

produce a canon which is beautiful, new, and charged with tradition, all at once.

Translated by T. L. Westow

Notes

1. A fair number of Eucharistic prayers, hand-written, typed or printed, has come my way. So I have been able to devote several seminars to analysing them. But in an international periodical one cannot limit oneself to examining the style of canons written in one or other particular language. It is therefore hoped that the reader will accept the somewhat general nature of my observations.

2. Apart from the four canons, approved for the universal Church, there is a collection of canons which have been approved in various localities: *Eucharisties de tous pays*, published by the C.N.P.L. (Paris, 1975).

3. Fortunately, the official canon 1 for a group of children—which could be used for adults just as well on condition of some modification in the dialogue—and the Philippine canon for children ('prohibited' today!) are happily free from such shortcomings.

4. The acceptance of the late formula *vel qui tibi offerunt* of the Roman canon, as if the *offerimus* applied only to the ministers, is one thing, but to relapse into mentioning the pope and the bishops before instead of after and in the midst of the Christian people is too much. What does one think of the dead being saved because 'God knows their righteousness'? Why use a harsh Augustinian formula like 'as he had lost your friendship by turning away from you, you did not abandon him to the power of death'? Why continue an equivocal statement about an effect of salvation that is proper to the sacrifice of the Mass by saying: 'the sacrifice which is worthy of you and redeems the world'? Why use the comparative to express the relations between God and the world: 'Lord, you are better than anything that exists' (Australia)!? etc.

5. Some of these collections show a distressing mediocrity. From among those available in book-shops, I mention the two referred to in the text because the St Andrew's collection shows a literary quality far superior to the average, and contains a remarkable critical analysis, while the Saint-Bernard collection is one of those where the Eucharistic character of certain prayers is rather discretely suggested than explicitly stated.

6. See A. P. C. Hanson 'The liberty of the bishop to improvise prayer in the Eucharist' *Vigiliae Christianae* 15 (1961) 173-176; P. de Clercx 'Improvisations et livres liturgiques: leçons d'une histoire' *Communautés et liturgies* 2 (1978) 109-126.

7. Huub Oosterhuis *Autor de la table* (Paris 1974, translated from the Dutch). The 'spiritual sacrifice' is often concealed and the role of the epiclesis is arguable. Some canons (e.g., 1, 2 and 3) show the classical formula. Others are more provocative but also more interesting, such as no. 12 (in spite of some expressions which would have been better positively stated rather than put in question-form); no. 14 (which re-introduces the narrative of the institution and inserts an epiclesis aimed at communion); no. 17 (for the marriage ceremony—rather long, in my opinion), and no. 18 (bereavement).

Michael Paul Gallagher

What has Literature to say to Liturgy?

We are in a state of radical distraction. . . . To possess your soul in peace for a few minutes you need the help of medical technology. . . . Is reading possible for a people with its mind in this state?

<div align="right">Saul Bellow</div>

To pray is to pay attention to something or someone other than oneself. Whenever a man so concentrates his attention—on a landscape, a poem, a geometrical problem, an idol, or the True God—that he completely forgets his own ego and desires, he is praying.

<div align="right">W. H. Auden</div>

IT SEEMS appropriate to open these few reflections on the lessons literature can offer to liturgy with quotations from a novelist and a poet who were both, in different ways, aware of the contemplative dimension of their art. The last few decades have witnessed many efforts to establish links between imaginative literature and theology, but some of these have seemed misguided: in so far as they approached literature as principally a source of religious insight, they neglected the unique power of literature, the fact that its value lies on the level of experience rather than of message. Similarly, this essay would propose that liturgy can be inspired by literature more in terms of a level of communication than in terms of contents.

Indeed there may be a particular relevance in this perspective today: the values of literature could highlight a serious impoverishment of post-Conciliar liturgy in the Catholic Church. One hears on many sides that the new liturgy, as normally enacted, lacks a sense of mystery, that it

has become levelled down to one mode, that it has become strangely inflexible and unable to answer the pastoral needs of a pluralist world, that it is often interpreted in an excessively horizontal manner, stressing human togetherness at the expense of mystical dimensions. In short, thinness and banality have sometimes resulted where relevance was intended, and a symbolic richness is lost which has not been compensated for by the intelligibility and participation potentials of the new rites.

Literature, by contrast, has often assumed the functions of worship or at least of spirituality for many readers of today. Almost exactly a century ago Matthew Arnold predicted such a role for imagination: 'More and more mankind will discover that we have to turn to poetry to interpret life for us, to console us, to sustain us', and he went on to claim that 'most of what now passes with us for religion and philosophy' would be replaced by literature. Setting aside the more secularist assumptions of his prophecy, Arnold's words have proved alarmingly accurate in some respects. In the contemporary culture of the West, many people approach the value-laden arts of fiction, film and theatre with something akin to worship and religious hunger. Artists such as Hermann Hesse, William Faulkner, Patrick White, Solzhenitsyn, Samuel Beckett or Ingmar Bergman have become cult figures in a time of frustrated religiousness. Where the Church mediations of mystery have failed to speak, the world of story and metaphor has become a substitute scripture and revelation and liturgy.

A paradoxical situation surely. Although the majority of modern authors have been far from any religious orthodoxy, they seem to have formed almost a conspiracy of hidden theology and secret spirituality. What T. S. Eliot (himself a most orthodox Christian) wrote about Hawthorne and Henry James might be applied to many of their successors in this century—they exemplified 'indifference to religious dogma and at the same time exceptional awareness of spiritual reality'. On another occasion Eliot offered a related and crucial distinction:[1]

Much has been said everywhere about the decline of religious belief; not so much notice has been taken of the decline of religious sensibility. The trouble of the modern age is not merely the inability to believe certain things about God and man which our forefathers believed, but the inability to *feel* towards God and man as they did. A belief in which you no longer believe is something which to some extent you can still understand; but when religious feeling disappears, the words in which men have struggled to express it become meaningless.

In this light it could be asked whether liturgy today is not suffering a crisis of religious feeling and whether this might not be more central than the

more evident crises of creed and culture. If so, the reform of liturgical externals urgently need completion by a renewal of internals also. And it is here that the world of literature could be of special service in reminding us of three areas of possible malnutrition in modern liturgy: (a) the level of spiritual receptivity of a congregation; (b) the medium of symbols and words as revelatory of mystery; (c) the various levels of communication possible within a celebration.

The area of pre-evangelisation or preparedness for worship

Both liturgy and literature require a certain level of receptivity if their richness is not to remain unattainable in experience. David Martin has analysed the convergence between aesthetic and religious consciousness in terms of the conditions needed for a genuine 'participative experience'.[2] For readers of this journal, it may be more helpful to draw together some ideas of Karl Rahner on the theme of poetry and imaginative writing as relevant to faith. An essay of 1959 put the emphasis on the 'greatest threat to religion' as lying 'in its *human* dimension', and on literature as a 'pre-religious' liberation of human potentials, capable of 'mediating the indispensable pre-requisites of Christianity'. In the course of Rahner's *Theological Investigations* at least five individual pieces expand on this basic insight.[3] A 'receptive capacity for the poetic word' is described as 'a presupposition of hearing the word of God', because in both man needs openness to mystery and hearing from the heart. But in fact the 'religious element' today is in danger of being out of tune with 'man's genuine experience', when it should be expressing that experience better and more deeply than he is able to himself; and this warning is extended to some overly enthusiastic uses of Scripture, as if it communicated automatically to man today. Thus, the preacher of God's word can be helped by being something of a poet, with a poet's gift of telling 'man his ambiguity in such a way that he perceives it'; and this is attained by means of *Urworte*, language that transcends utility and the shallow clarity of appealing to the mind alone. In this respect creative writers are viewed as capable of saving us from the banal, from being smothered by 'the forces of all that is average'.

Even from this rough summary, it should be evident that these themes in Rahner are relevant for our discussion of liturgy. Does liturgy need to regain the courage to be special and sacred? Has it too easily assumed that involvement means inner participation? (cf. *Sacrosanctum Concilium* 19) More particularly, has it neglected the dimension of interiority in the course of its valid and exciting reforms of rites? These are some of the questions that the literary world would put to liturgy today, in the hope that liturgy would find new means to create wonder and silence, to evoke something of the attentiveness of the aesthetic experience in a context of

worship. The success of literature as a kind of private spiritual liturgy for many people today is a reminder of the quality of experience required. Thus the world of literature would join forces with Eastern spirituality in encouraging liturgy to be more slow, silent and solemn. In Hamlet's words, 'the readiness is all'. Preparedness for prayer is our first crisis area raised by thinking about liturgy in the light of the aesthetic-contemplative experience of literature.

The Verbalist versus the Parabolic

In recent years there seems to be a new danger of disobedience to the counsel of Christ that one should not use many words in prayer; and the liturgist does not have to wait for the literary man to point this out: at least two recent surveys of the state of liturgy diagnosed an 'excessive verbosity' or 'verbal inflation' in contemporary worship.[4] Paradoxically, literature which is rooted in the verbal is also a reminder of the perils of verbalism—of thinking that an accumulation of words means an accumulation of significance. An internationally successful drama such as *Equus* is a classic example of fraudulent verbalism in recent writing: although superficially impressive, it mistook cleverness for wisdom and mystification for mystery; its audiences were excited with powerful verbiage but the taste turned sour on reflection, on looking for human reality. The lesson for liturgy is obvious: if words in drama belong within the eloquence of a human situation, words in worship must be held suspect unless situated in faith and in the actions of a believing community. 'Words alone are certain good' was the chorus of Yeats's first collected poem, but it is a dangerous motto for dramatist or liturgist. It forgets, to cite a rather different line of Eliot's, that 'words after speech reach into the silence'.

If the previous section dealt with the pre-verbal area of receptivity, this section asks rather about the role of words in a basically dramatic medium. Aristotle put *lexis* third in his list of the elements of tragedy, and with a sure instinct gave precedence to *mythos* and *ethos*, the realms of story and of human values. Some contemporary drama has witnessed a radical subverbalism as exemplified in the works of Beckett. Here the focus is on the tragedy and the comedy of man's inability to live without words even though they are only empty counters filling in the time; and in his more recent work Beckett embodies man's essential poverty in gestures of silence. Once again a possible warning emerges for liturgy against giving language the centre of the stage.

And this warning is all the more necessary if the language in question is doctrinal in a conceptual manner; in fact this would constitute a second infidelity to the example of Christ who never spoke to the crowds except in parables (Matt. 13:34; Mark 4:34). Not only from literature but also

G

from the scriptural emphasis on the parabolic the liturgist can relearn the simple truth that man is a story-loving animal, and that this has a relevance beyond any mere improvement of communications. The parable is not simply a tool of rhetoric, a means of attracting interest in the congregation. If imagination is not valued as a 'form of thought', then faith, theology and liturgy 'will only use the images of literature . . . in a secondary and unimportant way'. For the Cartesian tradition of clear ideas, parables were for didacticism, useful vehicles of moral messages. In the Coleridgean tradition, where symbol is not so automatically reduced to allegory, the parable is more an extended metaphor, a trap for echoing wonderment.[5] If so, our preaching should be more parabolic and less rationalist; it should create echoes rather than offer explanations. Such at least would be the advice of Robert Frost, one of the masters of parable and indirection in modern poetry: allow hints to set up reverberations within consciousness, to arouse 'the pleasure of ulteriority'. Or, finally, on this point, one may recall a celebrated saying by another American poet, Wallace Stevens: 'poetry must resist the intelligence almost successfully.'

The conclusion emerging here is that liturgy becomes dreary when it limits itself to the language of concepts, when it overloads itself with explanations for the mind, when it forgets the symbol as the most appropriate medium for mystery. The vast success of modern literature as a vehicle of spiritual quest gives testimony to this power of symbol and of story in embodying human complexity and in reaching human hearts.

Flexibility of Styles

One of the great moments in the patristic theory of Christian communication involves the revolution brought about by St Augustine in the history of rhetoric. Having been professionally occupied with this discipline for some twenty years before his conversion, his *De Doctrina Christiana* shows his way of rethinking his old skill in the light of his new faith. His insight was that now he would love the truth in words rather than words themselves (*in verbis verum amare, non verba*), and his innovation is to break down the strictly separate divisions of style in classical rhetoric.[6] The Christian sublimity of subject-matter was to join with a simplicity of eloquence in a way unheard of in antiquity, and even the plain style is allowed to become exalted, not by ornament but by power of feeling. This example—of introducing new flexibility into an older decorum—may seem far-fetched here, but it is a way of suggesting a flexibility in modes of communication that modern liturgy may have lost. One of the greatest spiritual poems of this century offers a parallel example: Eliot's *Four Quartets* deliberately exploits high and low styles in contrast with one another, setting passages of rich density side by side

with passages of stark colloquialism, and thus miming something of the flux of spiritual states.

Would it be against the split of the new liturgy to encourage a similar and quite marked difference of wavelength between the liturgy of the word and the liturgy of the eucharist? Just as literature communicates at varying levels of intensity, even within one work, so too liturgy may need a conscious variety of levels of action. It needs to be able to range, even within one celebration, from direct human contact through communal inwardness to solemnity.

The limitations of the literary perspective

One should note that in many ways literature is an unsuitable partner for dialogue with liturgy. Apart from drama, the literature of the last few centuries has assumed a very privatised world of isolated consciousness; increasingly, what is termed 'literary' has been the product of an alienated and élitist minority. From this point of view it has serious limitations in any convergence with liturgy as a community action involving many kinds of people.[7] As approached here, literature has been seen as a stimulus for one dimension of liturgy, the sometimes forgotten dimension of depth and the indirect modes of discourse that awaken that depth more truly than the language of the head.

To put the proposals here in larger perspective, one can suggest that there are four dimensions that enter into maturity of faith, and that if liturgy is to reflect and cultivate maturity of faith, it will need to do justice to all four aspects. The first is the element of the Church as tradition and community of faith. The second is the realm of revelation, of encounter with Christ and personal conversion. The third is the changed life-style that results from the surrender of faith, the whole area of social commitment and love. The fourth is the inward or contemplative dimension, the realm of interiority, of man's searching in various ways to find himself and to be found by God. Post-conciliar discourse on liturgy has focussed on community, on evangelisation, and on linking worship with engagement in the world—the first three elements. The fourth element of interiority has tended to be not so much forgotten in theory as left impotent in practice. It is the element that literature thrives upon, even to the extent of becoming a gnostic wisdom forgetful of community, revelation and commitment. Modern literature has been intensely religious in its mood and its questions even when it is largely agnostic in its matter and its answers. Liturgy by contrast cannot assume that the religious question is alive or that the religious awareness is alert in a congregation. Hence modes of preparation become vital and a broader ambitiousness on the spiritual level seems essential. Without this dimension the stress on community becomes cosy, the good news becomes unhearable at any

depth, and the urgency of social commitments become unrooted and in danger of the withering spoken of in the parable of the sower. From listening to literature, liturgy will not solve all its problems, but it will receive a healthy challenge and a reminder that it needs more than intelligibility to do justice to the mystery of God and of man.

Notes

1. 'The Social Function of Poetry' in *On Poetry and Poets* (London 1957) p. 25.

2. F. David Martin *Art and the Religious Experience: The 'Language' of the Sacred* (Lewisburg 1972) chap. 2 *passim*.

3. The quotations in this paragraph are from various essays of Karl Rahner (these references being to the English editions): *Mission and Grace,* III 119-122 ('On the theology of books'); and the following from *Theological Investigations:* 'Poetry and Christian' IV pp. 357-363; 'The Future of the Religious Book' VIII pp. 252-253; 'Priest and Poet' III pp. 296, 313; 'Prayer for Creative Writers' VIII p. 131. See also in the same volume 'The Task of the Writer in Relation to Christian Living'.

4. James Hitchcock 'La Voix du silence' in *Communio* 3 No. 6 (1978) 71; Joseph Gelineau *The Liturgy today and tomorrow* (London 1978) p. 77.

5. The quotation in this paragraph is from William Lynch 'The Life of Faith and Imagination' *The Month* (January 1979) 8. On the parabolic see Sallie McFague TeSelle *Speaking in Parables: A Study in Metaphor and Theology* (Fortress Press 1975).

6. 'De Doctrina Christiana' *Patrologia Latina,* ed. Migne 34, 1845. On these points see Christine Mohrmann *Etudes sur le Latin des Chrétiens* (Rome 1958) 1 360, and Erich Auerbach *Literary Language and its Public* (London 1965) on the *sermo humilis*.

7. The Canadian cultural journal *Mosaic* announced a special issue on 'Liturgy and Literature', for 1979, but it had not appeared by the time of writing this article.

Crispino Valenziano

Image, Culture, Liturgy

1. IMAGE, ANTHROPOLOGY AND THEOLOGY

THE atomic bomb on Hiroshima of the 6th of August 1945 seems to me a symbol, almost a trope of the transfiguration sung the wrong way round for the unconfessed loss of sight in the face of man. Ever since Clement of Alexandria, we Christians have repeated that man resembles God because God resembles man, and since Gregory of Nyssa that man is the human face of God. Additionally, both within the contexts of Christian cultures and outside them, anyone looking at man characterises him with qualities assessed on the premise 'to the image and likeness': intelligence, freedom, capacity to plan . . ., divine essence, divine race, impotent god, god-man. From Aratus and Cleanthes or from Heidegger to Feuerbach the names suggest, however crazily, the true reality.

But it would be inaccurate and unjust to see man, the man of our time, as calcified on the 6th of August at Hiroshima. The incident seems to me symbolic as a threshold between two civilisations, between the tragic end of the second millennium and a laborious beginning to the third millennium. One should listen again to the passage on 'prophets of misfortune' in the speech by John XXIII at Vatican Council II on the 11th of October 1962, and to the passage on 'humanism that becomes eccentric Christianity' in the speech by Paul VI at Vatican Council II on 7 December 1965. They contain an interpretation of the signs of the times, of anthropology and theology, which are useful and necessary to the present theme.

In our epoch man has reached the threshold-point through the evolution of his inner conscience, and human cultures have fulfilled their actual dynamic stages, achieving them, admittedly at great acceleration, consistently all together and in polarity. Everywhere today man is carefully attentive to his own totality, meaningfully outstretched towards more

complete and more intensely correlated new cultures. Rarely in history have convergences been as favourable to the perception of Christian themes concerned with the 'iconic' approach of anthropology and with Christian models concerned with the 'sacramental' standpoint of theology. It would be counter-productive alienation not to realise this but to insist on interpretations and activity based on enlightened *a priori* logic. It would be a senseless subterfuge to deprecate further the 'civilisation of the image' as a civilisation identified with neo-positivism and materialism. Since in fact it is the phenomenological event that established the synchronism, there is no great daring in establishing in Christian cultures structural equivalences between the depreciation of the person, the secularisation of society, the juridicalism of ecclesiology, the formalism of liturgy, the atypicism of spirituality, the non-mystagogy of catechism, the praxicism of pastorality, the intellectualism of theology and the eclipse of the image—any eclipse, from physical and mental insignificance to metaphysical and artistic disfiguration, with all the burden and implication involved. Whatever the connotations of the first members of these pairs, the image remains in an anthropological and theological circle, negative and positive, in relation to each of them and to all of them together: from man to Church, from the Bible to faith, from experience to testimony.

I am fundamentally in agreement with the affirmation that Hellenism in comparison with Hebraism is visual culture as against auditory culture, even if G. Kittel in *Die Religiongeschichte und das Urchristentum* observes that in the messianic biblical texts 'Hear O Israel' yields to 'Lift up thine eyes and see'; and P. Evdokimov in *L'Art de l'icône* reads Job 42:5, 'I had heard of Thee by the hearing of the ear: *but* now my eye sees Thee'. It is a question of intensity, not of exclusion. It would be crude, however, to accept the 'Hellenic' Christian cultures for their iconological components and the 'Hebrew' Christian cultures for their biblical components; as if the teaching of John and Paul and the New Testament in general did not remain the fount of all Christian cultures within the whole arc ranging from hearing to seeing.

One absolute hypothesis is the postulation that man, and so much more the Christian, could not do without beauty without diminishing himself, even losing himself. According to Gregory of Nyssa man made to the image of God strives to become that image because his own likeness to God is a manifestation, an epiphany of the beauty of God. In the same sense John Climacus tells of the saint who, looking at the beauty of a woman, cried for joy and sang to God. The civilisation of the image emerges in cultures which are each in their own way sensitive to beauty. And even if the beauty of human vision is ambiguous, such sensitivity must not condemn that civilisation: it is an ambiguity that subtracts

nothing from the progressive Christ-like transfiguration of the universe; rather it defines the obligation of the Christian in the world and nourishes it to augment its quantity and quality.

Do I identify beauty only with the visual image? Not precisely. But the fact is that beauty always espouses light, since light and life are one. *Christus Pantocreator* opens his gospel at the passage John 8:12; and there is a widespread myth in many cultures of the ray of light that penetrates the darkness of the oyster and generates the pearl. . . . And there is another that the eye is the most privileged organ and sight the most privileged sense because it is patient of metaphor and symbol of the most comprehensive kind, not excluding the divine. Every artist, painter, sculptor, architect, musician or poet *sees* nothing 'ugly' and offers his eyes to let them bring him vision of everything 'beautiful'. The Holy Spirit, 'the finger of God's right hand', who 'renews the face of the earth' directs 'illumination' and 'illuminates' those whom the Spirit has made reborn from the water. We should also listen again to our Lord in Matthew 6:22-23. The metaphor to be taken in both an allegorical and anagogical sense, in the context that from Origen to the pseudo-Denys the Areopagite and beyond hands on the doctrine of the 'spiritual senses', underlines unifying perspectives from which man emerges, as Macarius would say, as 'the only eye'.

It is not materialism of the spiritual nor aestheticism of the divine; it is the 'divinisation of man'. But by the same token, it is the human realisation of the artist and of anyone else that purifies the 'lucency of the eyes'.

At this point I expand on the subject of the symbol and of symbolism.

Let us follow the deliberations of the second Council of Nicea. (It is better if we read it in collation with the Synod of the Blachernae and with the *Libri Carolini*.) All the problems considered gravitate around symbolism, since the symbol is a sign which is a factor of *presence,* not a pointing index finger, which is a sign which implies absence. And the iconological question is a question of the typology of presences: Is the icon a symbol or an index? Up to which point is it one or the other, up to which point one *and* the other? Under what conditions is it the only symbol of the Christ-mystery? With regard to the relationship between image and word delineated at Nicea II, their equal potential was confirmed and emphasis was laid on the dynamics of visual beauty; colour and substance point to the possibilities of transcendence; the circumscribability of Christ is attributable to the real incarnation of the Word; the consistency of the painted nave is identified with the prototype of the image named; the Eucharist is distinct from the icon—and this hints at a typology within the specific symbolic presence.

Let us jump a millennium and come to the problems of 'new art'. 'To

present, not things, but their meaning'—'Modern art is subjectivist presentation': these are the extremes of the debate. Now symbolism, approximately defined, refers to the typologies of generic significant presence which, although extending eventually to true symbolic presence, limits its interest to the general comprehensiveness of what is significant and what is signified. In so doing it skips over the most important nuances in the whole spectrum of images extending from analogous 'images' to the visual 'prime analogate' image. The axioms previously stated hold equally whether relative to visual language or auditory language; while the real relevant symbolic question concerns the completely original visual sign and, for example, the *poetic* verbal sign, but excludes from its ambit the *didactic* word equally with the comparatively rare *facsimile* image. Now the aesthetic presentation offered to us by modern art can be sad because it is significant-image devastated in its expression and significance-image inadequate in its communication, but then it is an image of a meaning that is *itself* devastated and inadequate: need one confirm that the presentation is in itself a real symbol of an impoverished reality? If expressionists, cubists, magicorealists, surrealists and abstract artists have proclaimed the importance of presenting 'the interior essence of things', 'images of being', not to be visibly registered by the naked eye, they are nevertheless fatally Luciferian in relation to God and they are Docetists in relation to his Christ. Perhaps Matisse depicts an authentic transcendence, Chagall outlines religious forms, Rousseau sees an evangelical infancy, Rouault celebrates the Christian mystery. The enchantment of many works of Klee is certainly begotten by the wonder which the inexplicable inspires in him; so that the enigma of his 'carpets' approached the 'liturgical toccatas' of Roman cosmati work. Is it irrationality?—may they correspond to the Arabic equations solved in the 'liturgical fantasies' of the Norman-Sicilian mural slabs? And as in the images of such people, so in the images of the subconscious of Goya, of the occultism of Bosch, of the overturning of Liepchitz, of the transsubstantiality of Moore, or in the diagonals of Malévitch and the right angles of Mondrian. With all these artists we are left with cultural experiences no less dramatic than iconoclasm and its complex pattern; we come back to the question of the symbol as presence. Sartre said that the yellow of the Crucifixion of Tintoretto *does not represent* dismay and anguish, *it is* dismay and anguish.

All this talk about beauty and perception brings us back to the relationship between image and presence. To separate the image from the presence-in-symbol is to imprison it within the confines of being visible to the naked eye, within the confines of the didactic word and its analogies. These are images which have their place in intellectual theory and human action but they are not the matrixes of a true, authentic 'civilisation of the

image'. If, on the other hand, the image is significant of mysterious meaning, then to separate it from the presence-in-symbol is to deprive it of any true theological significance. The images which Gregory the Great sketches for the instruction of the ignorant are images of this type; and if the Carolingian culture were not wrong in believing that the identity of image, symbol and presence was absurd, the *Libri Carolini* would be right in everything.

We must add two observations:

The first is that the symbolisation of the image is not a question of technique: or rather, it is not a question of technique alone, and eventually it is a question of technique as a secondary issue. From the time of the second Council of Nicea 'rules' were established whereby the iconographer became 'hagiographer'; but even though starting in the 'sacred art' of the third dimension and of perspective, of chiaroscuro and the optical illusion, it originated the separation of the mystery-image from the presence-in-symbol. I would not be so sure that the theological insignificance of too much of the corpus of sacred art derives directly from such 'irregularities' as to believe that the Franciscan Giotto is at the root of western iconological disasters, or that Fra Angelico lost himself and went astray in his Dominican preaching. As long as the presence-in-symbol does not decline! As a proof of this, the suggestion of Athenagoras I on the urgency of the renewal of Byzantine iconography occurs to me (see the entire chapter 'Leitourghia' in O. Clément, *Dialogues avec le patriarche Athénagoros*). It could constitute an ecumenical encounter: Western 'subjectivity' or 'realism' meeting Eastern 'theology' and 'liturgy', Eastern 'traditionalism' *vis-à-vis* Western 'creativity' (the coining of that term from the verbal form 'creare' is by Athenagoras himself).

The second observation is that a reform of the space-time 'norms', such as the image-symbol is, produces a realisation of man which is simplified in unity. Perception is, then, truly a 'field' in which circulates all that is lived, experimented, learned, all that is codified, precomprehended, awaited . . .; and therefore what is seen goes beyond the 'objective'. Already an ordinary objective spectator is unreal, as alleged scientific objectivity is unreal: positivism is bankruptcy up to that point, the point of imagining the subject involved and enwrapped in symbolic communion!

We have, then, to recall as never before what was reflected in the seventeenth century and what Bergson underlined beyond Vico: perception rooted in an embracing corporality and in memory that is also imagination, has a duration of its own into which enters all the freedom which, in truth, the spirit shares with nature. In the communication which

is a circularity of presences there is established a reciprocity of consciousness which is an anthropogenetic circle between symbol and subject, and vice versa.

2. IMAGE, ASSEMBLY AND CELEBRATION

It is within this setting that the renewal of image becomes part of our liturgy; not as within a frame, but as a determining and qualifying component. In fact the 'ritual' image is a cultural constant which lies between the constitution of the 'sacred universe' that every culture conceives and the constitution of *homo liturgicus* which happens in every culture, both being members in symbiosis. The constitution of the 'sacred universe' of Christian cultures is a mystery and is bestowed; the constitution of the Christian *homo liturgicus* is sacramental and is a grace; but this does not alter the fact that Christian cultures form an otherwise symbolic perspective of the mystery and the sacrament, with consequently different ritual anthropogeny. Furthermore the rite is constantly 'symbolic realism' and the ritual image participates in the same realism. In our case it is a matter of the realism of mystery and sacrament, but this does not deny the fact that our images risk being symbolically realistic merely in a conventional or even magic perspective according to the different ways in which the symbolism of mystery and sacrament is arranged. Every ritual image tends to be called 'acherotypical' (not made by human hands) and 'miraculous': whoever executes it or gives it the denominative touch, it is *not the hand of the iconographer* and its execution is *always a marvel to the eye*; one should study again the numerous myths, Christian or otherwise, so charged with presence, expressed in paintings, sculptures and architecture. But the Christian ritual image is an expression in the vocative case and not simply a nominative verbal description, it is a verb of action in the imperative mood and not simply indicative. It is an interrupting, interpersonal mark of interpellation: evocation not as a recollection, invocation not as a request, but a true and dignified anamnesic epiclesis. This *contains* the marvel of the works which are *mirabilia Dei* and the doxology of man *doxa Dei*.

One used to speak of 'renewal' of the image in our liturgy. It is not difficult for anyone, and it proves our thesis, to go back to the synchrony (we repeat this now in the positive) between such a phenomenon and *renewals* in the anthropological aspect, in social sacredness, in the sacraments of the Church, in the mysteries of the liturgy, in the typification of spirituality, in catechetical mystagogy, in pastoral neo-praxicism, in the pneumatics of theology.

At this point the thesis considers the typologies of image in liturgy.

1. *Image of the assembly—image in the assembly*

Our image-civilisation has established itself through the explosion of the instruments of visual transmission. This has a double reaction in our case: as transmission of projected images at the liturgical assembly, and as transmission of the images of liturgical celebration to receivers outside the assembly congregated *hic et nunc*. We do not at the moment consider the first side of the duality, but the second—what we call the 'image of the assembly'. We are in the semiotic sphere of communication and the situation to which we are addressing ourselves is the possibility of an assembly meeting beyond the limitations of *hic et nunc*. It does not seem to me that adaptations of the 'physical' and 'moral' presence at the television phenomenon or the televisual potentiality of a category of 'visual' presence in psycho-sociological intensity are acts that resolve this dilemma. In my view one cannot disregard a resort beyond the generic category of 'participation' exemplified by the specific liturgical participation which is 'ministerial communion': the assembly which meets *ad Patrem per Filium in Spiritu* is the Church in a state of permanent edification and in the temporal reality of supreme edification. The state of *sine dominico non possumus,* taken also in the *hic et nunc* sense of the liturgical gathering, is the condition governing the ministerial exercise of the participants. (Obviously our remarks do not reflect on the rights of the disabled, nor the obligation of information, nor the duties of precepts and observance.) At this point however I should observe that ministerial communion seems to me to be adequately served by direct closed circuit in the same assembly (one thinks of St Peter's, one thinks of St Peter's Square . . .). The same can be said of unrepeatable celebrations in other actual assemblies, assemblies which *celebrate* the Mass of the Chrism, receiving into their cathedral church from the actual celebration the liturgy of the Word and continuing 'their' eucharistic liturgy. Would one not *exalt* the true tone of that Mass (which certainly does not diminish the status of the ordained priesthood)? Would one not succeed in this way in translating into visual symbolisation (from the progressive culture of the image) the Latin invention of *fermentum* of the Byzantine invention of the *antiminsion*? However, these are cases of mixed typology: the image *of* the assembly *to* the assembly.

2. *Real image—projected image*

The image at the assembly for the celebration is 'real' and not 'projected' if the executant does not impose a controlling expression on his own representation of the assembly. Again we are in the semiotic sphere of the representation and the expression, because we are concerned with the symbolism and the symbolic realism of the liturgical image. With a simple television dolly-shot of this nature from a static or wheeled camera

we do not succeed in touching the horizon of real liturgical images and of their ritual synergy, except by indications, hints, allusions: the images of *time*, Sunday as an icon of the Resurrection, the morning as an icon of the Incarnation, the evening as an icon of Creation, the ritual year with its psychological, social and cultural iconology; the images of *space*, the altar icon of Christ, the pulpit icon of the Garden and of the empty Tomb, the iconic assembly edifice of universal celebration, architecture and its anthropological iconography; the images of the *human body*, its movement and its plasticising, fluid in shape and clad in colour; the images of *humanised objects,* furnishings and the like, the iconology of the 'sacred universe'; the images ordinarily intended as such, in sculpture and painting. Sculpture has its facile tendency to idolatrous seduction based on the powerful suggestion of an all-round comprehension: even if, as Cellini says, one has never seen a beautiful figure from every side there are eight basic points of view and at least twenty-four secondary angles from which—we are still quoting Cellini—the perambulating spectator can take in the work; therefore, from the status of 'intermediate art' between architecture and painting, sculpture can alternate and swing up to the height of an autonomous icon; and therefore it can be elevated to levels of ritual animation; and therefore one must commission the sculptor to carve directly onto the medium, since by that method the production is slower and more reflexive, and one must invite the liturgical spectators to purify the eye into virginity and indulge the other senses in this regard, since contemplation is less equivocal and more keenly symbolical.

Painting, whether in fresco on damp plaster, burnt in encaustically, as mosaic, glass or enamel, in oil or in miniature, marked out in niello or other media or coloured as embroidery or in textiles—all these have a wider physical scope and therefore a greater aesthetic freedom in all their forms. Consequently they are more liberating, their forms and their syntheses are more ductile and their symbolism is more faithful. For this reason painting refines the colours of mundane memory, purifies the enslaved eye of the prosaic, enables us to see beyond the trivial systems of the day more and better than any other art. Therefore one must envy the artist-painter, and not impose on him any further schematic systems. One must invite him in particular to become the hagiographer, and one must then invite the liturgical spectators to 'let themselves be captured' by the symbolic colour.

3. *Image of reality—image of the scene*

The projective image at the assembly in the celebration takes us rigorously back to the semiotic sphere of the language in which it is being conveyed, because our object is to surpass the language of information. Now the projective image is an image where its executant does not

impose a controlling expression on his own representation; but for this reason it is not a strictly informative image. A photographer is a person who 'writes with light'. There are two consequences. On the one hand he consistently intervenes in the registration: one must remember the sophisticated and mutually influential skills of focussing and squaring up, of cinematic artifices and effects, the editing, the determination of sequences. On the other hand, the viewer must decipher a product which is continuously mechanical: one needs to recall the intrusions and domestic accretions which materialise as parasites to the message. The fact is that in this present thesis the symbol is culturally connotative (not denotative) in putting through an average of considerable quality. Yet one succeds ritually, in my opinion, where one records reality, not scene. We may call 'scene' a fact or situation already essentially put across by artifices of various kinds. We may call 'reality' a fact conveyed only by iconic artifice.

Always, in my opinion, the recording of the scene is informative even if transmitted directly, whilst the recording of reality succeeds in being performative, being a matter of living reality transmitted in normal psycho-sociological conditions only if it is put out directly.

Everything that has been dealt with in this thesis, therefore, should be read synchronically.

Translated by Joyce Andrews

Bibliography

I give a brief bibliographical selection of general orientation. I allow myself to refer to my *Prospetto per una trattazione antropologica del simbolo nelle nostre culture cristiane* in *Symbolisme et Théologie* (Studia anslemiana 64. Sacramentum 2) (Roma 1974) 29-44, towards an eventual integration of the context (and of the connected bibliography).

AA. VV., *La comunicazione audiovisiva* (Roma 1972).

AA. VV., *Liturgia e strumenti di comunicazione sociale* (Quaderni di 'Il nostro cinema', 2), Roma s.d.

Barthes, R., *Rhétorique de l'image*, 'Communications' 4, (1964) 40-51.

Berenson, R., *Vedere e sapere*, (Milano-Firenze 1951).

id., Estetica, etica e storia nelle arti della rappresentazione visiva (Milano-Firenze 1953).

Cassirer, E., *Philosophie der symbolischen Forman* (Berlin 1923) ss.

id., An Essay on Man (New Haven 1944).

Fast, J., *Il linguaggio del corpo* (Milano 1972).

Francastel, P., *Peinture et société* (Paris 1951).

Itten, J., *Art de la couleur. Approche subjective et description objective de l'art* (Paris 1973).

Keim, J. A., *La photographie et l'homme. Sociologie et psycologie de la photographie* (Tournai 1971).

Kepes, G., *Language of vision* (Chicago 1944).

Libague, P., and Speri, G., *L'immagine come liberazione. Spunti per una cultura alternativa* (Firenze 1972).

Mercier, G., *L'art abstrait dans l'art sacré* (Paris 1964).

Merleau and Ponty, M., *Le visible et l'invisible* (Paris 1964).

id., *L'oeil et l'esprit* (Paris 1964).

Metz, C., *Au-delà de l'analogie, l'image* 'Communications' 15 (1970) 1-10.

Mounin, G., *Pour une sémiologie de l'image* 'Communication et langages' 22 (1974) 48-55.

Munari, B., *Design e comunicazione visiva* (Bari 1968).

Panofsky, E., *Die Perspktive als symbolische Form* (Leipzig-Berlin 1927).

id., *Meaning in the Visual Arts* (New York 1955).

Pierce, J. R., *Symbols Signals and Noise* (London 1962).

Thibault-Laulan, A. M., *L'image dans la société contemporaine* (Paris 1971).

id., *Le langage de l'image* (Paris 1971).

)

Bernard Huijbers

Liturgical Music after the Second Vatican Council

SO much new material has been published and even more is still in the throes of development and transition, that it is hardly possible to give an adequate account of the present state of liturgical music. However, it is possible to draw up an inventory of prevalent ideas with the help of available experiences, in particular those provided by the regular meetings of Universa Laus, an international group of people engaged in liturgical music.

Words such as 'new' and 'development' are hardly appropriate in this context and should be replaced by 'making up lost ground'. What is now called 'new' was already growing during the Reformation, also in the field of music, and led already long ago to musical climaxes in the works of composers like Schütz, Bextehude and Bach. The uncompromising attitude of the Counter-Reformation could result only in violent reverberations within the Roman Catholic Church. It caused a great deal of damage but, strangely enough, it was the means whereby some spectacular leaps ahead were made.

Music is an integral and constituent part of the liturgy and there is a close correlation between the two. I intend to describe this interaction in three phases, progressing from the obvious to the deeper causes lying within. These phases cannot be clearly separated. The distinction is more a methodical device and the sequence is phenomenological and diplomatic rather than logical.

1. *Interaction between music and other elements of the liturgy.* Here the question 'What?' will be asked, dealing with the repertoire in relation to the text, action and order of service. Dance and architecture will not be discussed.

2. *Interaction between the congregation celebrating the liturgy and the congregation performing the music.* Here the question 'Who?' is posed, concerning the proceedings.

3. *Interaction between the contents of the liturgical and the musical elements.* This raises the questions 'Why?' and 'To what purpose?' in other words, the ideology of the occurrence.

Phases 1 and 2 are followed by short intermezzi dealing with confrontations between old and new. These confrontations form part of the present musical situation and are not only caused by but also the cause of what is happening today.

1. MUSIC AND OTHER ELEMENTS OF THE LITURGY

(a) *Music and text*

The text *repertoire* (the texts of the musical repertoire) is in the course of radical change. Before the Second Vatican Council there was an absolute domination of composed texts from the Ordinary over a disappearing minority of motet-like texts. The music for texts of the Proper, intonations by the celebrant, melodies of lessons and vesper psalms, etc., were seldom or never composed, but borrowed from Gregorian chant. Since the Second Vatican Council this situation has been reversed. This, in itself, has caused an enormous rise in the *number* of compositions, as there are thousands of texts of the Proper and only five texts of the Ordinary. This total can then be multiplied not only by the many different languages but also by the number of groups within the parishes (young-old, popular-classical). The result is an abundance of compositions throughout the world, difficult to identify and not interchangeable, unlike the compositions of the Latin Ordinary of the olden days.

The *character* of the compositions appears to have changed. Before the Second Vatican Council, compositions, with some exceptions, used to be subjective, lyrical expressions arising from texts which were very often interpreted in a rather primitive way. Since the Second Vatican Council there has been a better understanding of texts, due in no small measure to the use of the mother tongue. The text is becoming more *dominant* in relation to the music because of a clearer theological perception of the liturgy. More attention is being paid to (1) the construction, (2) the style and (3) the function of the text. At the same time the *quality* of texts (e.g., in translations of psalms for use in the liturgy, of the Ordinary and of prefaces), the *choice* of texts (e.g., psalm responsories) and the *structure* of texts (e.g., when writing a text for different performers) are now also dependent on the feasibility of musical composition.

(1) More attention is being paid to the *construction* of the text, as can be seen by the use of old forms such as the two-line psalm verse or the versification of a hymn, and by the use of new forms such as the strophic composition of hymns for choir with a refrain sung by the congregation, the sung Eucharistic prayers and the texts for rounds.

(2) More attention is being paid to the *style* of the text used. There are old types such as acclamations, the oratorical style in the recitation of lessons and prayers, the less restricted style of antiphons and the more restricted style of hymns. Then there are the new types such as free verse in chanson-like compositions which are comparable to the ancient type-melodies, otherwise called nomos-melodies or tone patterns. It is probably true to say that really new literary and musical styles are hardly conceivable.

(3) More attention is being paid to the *function* of the text. The text may be a lesson which nowadays is less often intoned on a recitative than formerly, except on certain occasions (e.g., the sung passion). The text may be used as a prayer which is now also sung less frequently than in the olden days, except in the case of litanies or the sung eucharistic prayer. The text may be an invocation, more often used nowadays than previously, e.g., in acclamations. The text may be applied as a response or a meditation, as, e.g., in responsorial psalmody which is now an ever growing repertoire. The text may be used as an accompaniment to an action, as in antiphonal psalmody or processional chant. In all these cases the function of the text is predominantly determining the music. Is such an interaction between text and music not an anachronism? Which poet still writes hymn texts? Which prose writer still pays attention to the use of recitatives? How many tradesmen still sing the praises of their wares? On the other hand the question may be asked: Who can prove that types cannot be revived if they acquire a new function and if there is a need for them?

1 (b) *Music and action*

The response of 'Yes' by bride and bridegroom, the response of 'Amen' by a congregation . . . Both are a kind of action, the literary meaning being less important than the act of speaking. Specific actions—a better word for them might be 'gestures'—are quite common in the liturgy.

The music is involved with these gestures. The distribution of psalms or the distribution of holy communion may seem to last a long time without music. Music shortens the time, because it is, by definition, a musical passage of time, and gives it sense or fills it with emotion. Music can also express this sense and this emotion in a sung text. The liturgical renewal has acknowledged the importance of such actions or gestures. They have

H

been given a new lease of life. The congregation is invited to participate in many of them, and both vocal and instrumental music are used, partly in an old role and partly in a new role. Regarding vocal music, much has been drawn from the Gregorian past and from ancient forms still in use in the Eastern-Orthodox Churches. Joseph Gelineau broke new ground in this field (as he did in the whole manner of approach to liturgical music), and thanks to him everyone nowadays knows what is meant by *processional psalmody*. Many communion antiphons have been constructed on this pattern, even though they may not consist of psalm texts.

But above all, the *hymn sung by the people,* particularly in the beginning and at the end of the service, has now firmly established itself. I believe the reason for this is that the opening (or closing) of the service is now experienced more as a collective event (the congregation starting or closing the celebration) rather than as an hierarchical ritual (the entrance and exit of the officiating minister). A hymn is very appropriate to express this collective character. However, hymns are sometimes used too frequently, especially if one is not sufficiently familiar with other musical styles, which does the liturgy little good.

One can argue about the fact whether a *litany* is more an action than a literary affair. Characteristic of it is the lengthy and continuous repetition. In some cases composers have successfully found a musical form appropriate to solve this problem. Here, too, there is an interaction. Without music there would be no litany and without a litany that kind of music would not exist.

1 (c) *Music and order of service*

'Order of service' means the sequence of constituent elements. This sequence in itself is also a component, but the *ordo* is a kind of underlying framework and is not the service itself.

1. That there is an interaction between music and order of service is obvious, particularly from the antithesis between musical and liturgical structures which was so characteristic of the liturgy before the Second Vatican Council.

The liturgical sequence was completely smothered by musical forms, although still recognisable in spite of a multitude of additions on the one hand and the erosion and contraction of some parts on the other. This occurred when the Gregorian Gradual was sung during rather than between the lessons, when the Sanctus ran into the Canon or the Agnus Dei was not sung during the breaking of the host.

This became worse when, in classical Church music, the chants of the Ordinary began to show a closer musical relation to each other, an *ordo* of their own which, because of importance and length, acquired its own focal

point in the so-called Mass of the catechumens. The chants of the Proper, usually in a Gregorian setting, were gradually overshadowed, not to mention the mixture of styles and times. The compositions of the Ordinary even acquired the title of 'missa', despite the fact that those parts of the text are least important and least liturgical compared with the parts of the Proper which vary continuously and are adapted to circumstances.

2. The hegemony of the Ordinary is now on the decline. However, influenced by history and because of other reasons, mostly musical, composers still tend to organise separate musical elements into one musical whole which looks similar to a cantata or an oratorio. I, personally, have experienced that tendency resulting in the composition of 'liturgies'. Joseph Gelineau tried to integrate all parts from the introductory rite to the communion rite into one whole.

I began to doubt if this were the solution. The principle of arranging musical elements seldom coincides with that of liturgical ones, which, of necessity, creates an inconsistency. Moreover, the components cannot so easily be used in another context, for another celebration. This leads to a special, fixed programme for each celebration which is contrary to the flexibility demanded from the liturgy now and in the future. It is a different matter where the *Eucharistic Prayer* is concerned, which is usually composed as one whole. It is a complete liturgical unit, and this fact is particularly obvious in the hundreds of experimental canons used, *praeter legem or contra legem,* in a great part of the world. The congregation as a whole often partakes in it, thus giving rise to new musical expressions and forms.

Intermezzo 1
Composition before and after the Second Vatican Council.

In general, Church musicians appeared to be badly prepared for the advent of the new liturgy. Movements to renew Church music were directed more towards the restoration of Gregorian chant and polyphony and the recognition of modern music than towards liturgical integration. In 1963 liturgists and Church musicians had not yet come to a full understanding of each other. Perhaps this was because the liturgical movement consisted primarily of *clerics* who were pastorally and theologically orientated, and the Church music movement consisted primarily of *laymen*, theologically and pastorally less well endowed. Using their best endeavours and sacrificing financial interests they aimed at the highest form of art 'for the honour and glory of God', but I believe they fell victims of prevailing aesthetics promulgating absolute music to be the highest form of art and relegating functional music to second place. Most musicians appeared to be blind to the fact that their Latin music failed liturgically within the congregation. They had been used to the lack of

understanding of real art on the part of the 'common people', which, in the eyes of the romantics, was even considered to be proof of the quality of the music. And so it did not really affect them.

The *ignorance* of many Church musicians concerned:

1. Criticism being levelled against the prevailing concept of the Ordinary;
2. The musical scope offered by closely following style and function of the text. Intonations for the priest or recitatives for the reading of the lessons had not been composed for centuries;
3. The possibilities presented by the musical accompaniment of liturgical actions. We had forgotten what processional psalmody meant. Litanies had been composed only 'for the glory of Our Lady'. They had become completely alien to us as supplications.

This ignorance developed into a lack of understanding, a growing feeling of not being understood, hardening into estrangement, frustration, unwillingness, hostility and opposition. As more professional composers retired from the scene, more and more semi- or non-professional musicians occupied their places, which resulted in a lowering of the artistic level of new compositions. So Church composers became the cause of what they themselves dreaded so much. This disastrous, vicious circle has not yet been broken, although the signs are hopeful.

2. THE PERFORMERS

The musical proceedings have been changed by new liturgical celebrations. Here, too, there is interaction:

(a) The *liturgical* celebration has changed musically because of the (different) music.
(b) The *musical* element has been changed by the renewed liturgy.

2 (a) Before the Second Vatican Council there were low and sung masses. An intermediate form did not exist, with the exception of some prototypes of the liturgy to come (e.g., *Bet-Sing-Messe* and *Deutsches Hochamt*), quasi-liturgical functions such as Benediction, and para-liturgical ceremonies such as Stations of the Cross. The rules for low mass prohibited *any* part of it from being sung. If sung mass was celebrated, the whole mass had to be sung. The celebrant, for example, was to intone the Gloria and to recite the Preface, even though he were unable to sing a note. Only the lessons were allowed to be read in the absence of 'ordained' lecturers.

This 'all-or-nothing' situation has now changed. During most cel-

ebrations one or other part is usually sung. Which part this is depends very much on the circumstances. The Instruction *Musicam Sacram* contained an official, graduated list of preferences.

This change is not just a minor affair but is of essential importance. From now on text and action are being examined as to the meaning and function, and it has become clear that music is more or less *indispensable*. The active participation of the congregation as a whole is also a substantial element which has made the congregation an essential, rather than *ad libitum*, co-performer of the music, sometimes becoming even the main performer.

In that way liturgy with music has become the rule and liturgy without music the exception. Music has received a more important role *as a consequence* of the liturgical renewal, but was also the *cause* of it. Music gives a meaning and a function to texts and lends significance to actions (e.g., procession or litany). It forges people into a congregation, it creates the possibility of group expression which is more than the sum total of all individual expressions. It can evoke emotions and makes the expression of shared emotions possible, it offers the opportunity to contribute one's personal feelings emanating from one's innermost experiences. In short, music brings about communication, making the congregation into a real congregation.

Accordingly, music which fails to bring about communication should be called *bad* music, and musicians who (*salva erronea conscientia*) are unsuccessful in bringing about communication or, worse, oppose it, are in the same category.

2 (*b*) The congregation takes part in the singing. Choir and priest are no longer the sole performers. Choirs tend to change or to break up, new ones are formed. Instruments such as piano, flute, percussion and guitars are coming into their own.

Music making itself has changed. The importance of the meaning and the liturgical function of texts and actions cause some types of music and some types of performance to disappear, and others, of which only traces were left, to come back into existence again. Such ancient types which have been revived have already been mentioned, e.g.:

—acclamations (sometimes in the form of a refrain or litany) by the people or the officiating clergy;
—recitatives by readers, ministers or precentors;
—antiphons sung by the choir or the schola;
—hymns sung by the people, with or without choir;
—the singing of rounds by the people, with or without choir.

Each of these types of music is connected preferably with a certain group of performers.

The change of style or rather the diversification of *styles* of liturgical music is even more drastic. I am using the term 'style' for what is indicated by words as 'folk', 'popular', 'beat', 'guitar', 'rhythmic', 'youth', and, in contrast to these, 'classical'. This terminology is perhaps somewhat vague (as is the word 'style'), but the reader will know what is meant by it. Liturgical music is apparently in the course of becoming *'class-music'*. As different classes and groups of society speak a different language (Oxford English, dialect, slang, vulgar, jargon, group language), so they also have their own musical jargon in which they communicate with each other, recognise each other and make themselves understood to each other.

It is not the liturgy which causes the differences. The liturgy adapts to them as the various groups become of age as congregations and in turn start to contribute their own language and culture. Since only a minority of them is familiar with classical music, increasing numbers adopt the popular style (although what is called 'popular' in Amsterdam will still be very different from what is called 'popular' in, e.g., Kinshasa). This is much to the chagrin of professional church musicians who are nearly all of classical descent. For many years now there has been an unbridgeable gap between popular and classical.

This is not due to the present liturgy. It may, however, be due to the liturgy of the olden days. In support of this notion I can only refer you to my booklet *The Performing Audience* (North American Liturgy Resources, Phoenix, Ariz., 1973² *passim*). Briefly, my argument is that the liturgical choir music pre-1960 has been one of the strongest influences determining all music, even the later so-called classical music in the West. However, it should be realised that the liturgical music of before 1600 was the product of a split-situation. On one side we encounter imported Christianity, the Latin language, Gregorian chant and clerical liturgy, and on the other the people, looking on, listening, 'hearing mass'. The logical consequence of this was a dichotomy in the western music *tout court*.

Perhaps the new liturgy offers the opportunity of bridging that gap, because the various 'classes' meet together in the congregation (in as far as the Church has not lost the intellectuals and the workers). Might it not be possible for Church music to be the means of solving not only a class problem within the congregation but, via the congregation, also the class problem in the world? This would be too good to be true.

The solution is not to be found in the quantitative domination of one class over another (I estimate that 80 per cent of all celebrations in the United States are 'guitar masses'), but in the quality of both popular and classical music. In this respect I have drawn attention to Carl Orff's concept of 'elementary music'.

Intermezzo 2

Performance before and after the Second Vatican Council.

Musicians automatically think in terms of performers and audience. It is the result of the present arrangement in the concert hall, which is the bourgeois version of what took place at court. This arrangement can probably be traced back to the centuries-old liturgical ceremony performed by a choir, part-singing in Latin, and a clergy, speaking in Latin, and in between them a congregation, either passively 'hearing mass' or not 'hearing mass' at all.

The performing audience virtually did not exist. Even today compositions of the Ordinary are still performed in concert halls without the incongruity of it being realised. In the case of the Missa Solemnis by Beethoven or the Requiem by Verdi it is not quite so absurd, but it becomes a different matter when a mass by Palestrina, a passion by Schütz or choral preludes by Bach are involved.

The liturgical repertoire, especially Gregorian chant, contains many master-pieces which are totally integrated with the text and/or the liturgical situation, and which can only be performed with the assistance of the congregation. In the new repertoire this is the rule. Many choirs, conductors and organists were apparently unprepared for this. They were adapted to a 'concert situation'. The disappearance of this meant for them a lowering of artistic standards.

The fear of it caused exactly that which they dreaded so much. Many of them could not continue to give their loyal and creative co-operation, and the result was the emergence of many new choirs, instrumental groups, temporary conductors, temporary organists, all equally helpless in the new situation. At the same time many old choirs with their conductors and organists were responsible for the continuation of many Latin high masses, often badly attended, even in those place where the situation clamoured for the use of the mother tongue. It created a tragic conflict which could have been avoided, had there been better information and guidance. Or were they interested only in performing music—whether 'for the honour and glory of God' or not—rather than in contributing to the best possible celebration of the liturgy for the sake of the people, clearly a case of the 'first' commandment without the 'second'?

3. THE CONTENTS

What appears to motivate people is also part of the picture. Anybody who chooses to ignore it and pays attention only to the result or the process understands little of what is happening, has happened or will happen.

It is not easy to find out what appears to motivate people. It is a secret process within one, sometimes even without one's being aware of it. Another person can only surmise, discover some connections and then put forward an acceptable assumption. But he cannot offer absolute certainty.

Such questions seem to be outside the scope of an article about music. They appear to be more concerned with the text or the order of service. However, what is sung in the churches and the manner in which it is sung give a good indication of what the people believe, of what motivates them. Old hymn texts expressing the vertical relationship with God are characterised by their melodies (although the reverse is not necessarily the case, because old melodies have sometimes been used for new texts). Orthodoxy and religiosity often show in the choice and types of hymns. A visitor to a church can conclude much from what he hears. He will become aware of a baffling variety of music and texts some of which may seem to be even incongruous and incompatible with each other. But he will soon realise that, fundamentally, they all have one factor in common. He will discover that the liturgy in the mother tongue has gone through one and the same process everywhere, i.e., the *democratisation* of language and rite. The purpose of it can have been no other than to democratise the contents. But this democratisation has hardly yet been realised. Where, in the olden days, liturgy was not much more than religion, there can still be found an emphasis on typically religious modes, such as obedience, a lack of biblical spirit, and a great deal of moralism. Obedience: Just as little was done before the renewal of the liturgy (most churches did not ask for the use of the mother tongue), so now the new *Ordo* of 1969 is accepted without any original contribution on the part of those accepting it, and uncritical composers follow in these footsteps. This is clearly shown by the act of penance, the greeting, the reverence for the bible readings, the official Eucharistic prayers (with a solemn 'Amen' of doubtful artistic quality), the texts used during the communion rite and the dominating role of the officiating celebrant. A lack of biblical spirit: In spite of the respect for the Book, many hymns are just repetitions, paraphrases in verse form. There is little personal understanding, individual assimilation or application of the Bible text. Moralism: These churches resound with the authoritarian 'you shall' or with the use of the royal 'we', but seldom with the personalised 'I am', 'I feel', 'I want', 'I know'.

Groups which forged ahead before or during the Second Vatican Council have seen their initiatives and ideas being incorporated into the new liturgy. To them we owe, e.g., new canon texts, the canon in the mother tongue, communion in the hand. They are still 'way ahead of others', if they have not been orphaned by the marriage of their leaders. Much of what they are doing is not given much publicity, often purposely

for fear of possible repercussions. Development stagnates, because 'it is not allowed by the bishop'. I know of cases in which responsible priests have been moved or dismissed. Active groups, known to me, have problems with the authorities in The Netherlands, Flanders, England, Germany and the United States. They use appropriate translations of the psalms and in their hymns they sing of humanity:

—loneliness, companionship, friendship and marriage,
—fears, suffering, death,
—justice, protests against injustice,
—power, helplessness, impotence,

often in a social and political context. Their religious character is marked by a *prophetical* Jewish-Christian criticism of religion. If they are familiar with transcendence, it is natural rather than supernatural. The more prophetic and Jewish (Christian), the more the text dominates the music. It then becomes critical what one says and equally critical is the manner in which it is said so that it is understood. Then the honour and glory of God become of less importance than the message of the text to the people.

Translated by W. M. P. Kruyssen

I

A. Ronald Sequeira

The Rediscovery of the Role of Movement[1] in the Liturgy

AS long as sixty years ago Romano Guardini surmised that a renewal of
the liturgy that was concerned exclusively with reshaping the words (by
introducing new texts, more understandable language, etc.) or with
reshaping the music (by using contemporary settings, expanding the
instrumental resources used, etc.) or with both would never achieve a
definitive break-through if at the same time it did not concern itself with
the renewal of a third dimension, one that from many points of view is
more important: the dimension of movement, of liturgical gesture, of
symbolic dance (often misleadingly labelled 'body language', as if word
and music did not also involve the body).

For Guardini the way to liturgical life led 'above all through action. . . .
Action is something elemental in which the whole human being with all
his or her creative powers has to be involved; it has to be an accom-
plishment that is alive; a living experience, perception, vision'.[2] In keep-
ing with this he attempted in his short book on sacred symbols to breathe
new life into the surviving remnants of the old liturgical language of
gesture. But he was aware that what was basically involved was a fun-
damental renewal of worship: 'The man who is moved by emotion will
kneel, bow, clasp his hands or impose them, stretch forth his arms, strike
his breast, make an offering of something, and so on. These elementary
gestures are capable of richer development and expansion, or else of
amalgamation. . . . Finally, a whole series of such movements may be
co-ordinated. This gives rise to religious action . . .'[3]

If one reflects that the various movements for renewal were under way
by the latest from the time of the Malines Congress of 1909, the question
can be asked why in the 1920s Guardini was arguing for consideration to

be given to the dimension of movement. The reason that suggests itself to the author of this article is that the first waves of renewal were concerned exclusively with word and music, with the introduction of the vernacular, for example, and the introduction of chants and hymns to be sung by the congregation, but 'at the start people had no criterion and no norm for how the faithful's share in action and prayer, apart from mere verbal responses, should be more properly organised. In many cases everything was simply prayed through. . . .'[4] To Guardini it was manifestly clear that, if the liturgy were the accomplishment of an action expressing the faith of the 'whole man', the customary manner of joining in with words and music ('mere verbal responses') was not enough. Liturgy is rather a combination of movement and action, an experience and at the same time an expression of the senses, an act of being present that involves the whole person.

It can hardly be claimed that this proposal of Guardini's fell at first on fruitful soil. From the historical point of view there had been a tradition of church dance right up to and including the Middle Ages, but this was followed by a period of stagnation which historians of the liturgy have called the age of rubricism (1614-1903). It was this reduction of the liturgy to a matter of rubrics that Guardini was attacking. But where would one be able to obtain more up-to-date liturgical gestures more in keeping with the modern world? A gulf had long since developed between the language of liturgical gesture and secular arts involving movement—at least as far as the West was concerned. What would have been necessary was a new language of gesture which was based on the basic gestures of the liturgy (which after all are quite simply the most elementary human gestures) and which helped the congregation to join in the liturgy in a living way. But for this the right kind of 'liturgical method'[5] was lacking. During the period before the Second World War what was emphasised was the role of word and music in the liturgy. It was the period of the *Betsingmesse*, the form the celebration of Mass took in German-speaking countries under the impulse of the liturgical movement, with hymns in German replacing Latin chants and with German used for much of what was said out loud: even today this can be described as the chief form of community prayer in the German-speaking world. In this there was only one opportunity for genuine movement on the part of the congregation: at the procession, a survival of the oldest form of man's religious expression.

It is only after the Second World War that we can speak of a rediscovery of the dimension of movement in the liturgy. Since the shape of Christian liturgies has for the most part been moulded by western forms of expression, this rediscovery is to be understood against the background of the recent cultural history of the western nations and their relations to

other parts of the world. In general, however, it can be said that the first half of the twentieth century was the period in which Western man rediscovered his bodily nature. As a result, among other things, of developments in the field of the social sciences, for example in depth psychology, the Church's deep-rooted hostility to the body was called into question. As early as 1932 Gerardus van der Leeuw wrote in the first edition of his book *Wegen en Grenzen*: 'The movement of the body often expresses more of the totality and the background of life than words or sounds are able to do.'[6] Soon after the war, Thomas Ohm published the work he had completed in 1944 on Christianity and gestures used in prayer (*Die Gebetsgebärden der Völker und das Christentum*, Leiden 1948), and in the same year (1948) Hugo Rahner, at an Eranos conference, argued for man at play, a Church at play, a liturgy at play.[7]

At first the *Betsingmesse* and processions were enough. The first years of reconstruction after the war—and the business of coming to grips with the recent past—left little room for the significant experimentation without which it would hardly be possible to make the liturgy an experience of celebration and play. It was only about ten years after the end of the Second World War that a turning-point seems to have been reached.

A whole series of factors were responsible for this, and we need mention only the most important. First of all we must observe that Christian theologians had rediscovered man. There was an increasing emphasis on the anthropological dimension of faith. At the same time, as is well known, all the Christian churches were going through a process of self-renewal, a process which as far as the Catholic Church is concerned reached its first culmination in the Second Vatican Council.

In this the first place was taken by the renewal of the liturgy. It cannot be claimed today that the Council's constitution on the liturgy was a downright revolutionary document with regard to the aspect of move-ment. But it had the effect of focusing attention: one had to look for forms of expression better adapted to the contemporary world.

The fact that interest in movement and in the language of the body first gained significance in the 1960s can be understood from the cultural developments in the period after the war. As far as the liturgy is con-cerned two factors need to be mentioned: first, the awakening of the 'young' churches of Asia, Africa and South America; and secondly the fact that in the West there had come to maturity a new generation which was itself engaged in the search for its own identity. Let us start by looking at the first of these developments.

The process of political decolonisation led to the emergence of local churches outside Europe which understandably were looking for a Chris-tian identity of their own. There was everywhere the desire for a Chris-

tianity of a non-European mould, for genuine native local churches. Thus it came about that as early as the start of the 1960s there was a relatively large number of small groups in various countries outside Europe which were occupied with the search for native forms of liturgical expression. These could hardly be overlooked at the Eucharistic Congresses held at Munich in 1960 and at Bombay in 1964. One unmistakable fact was that for non-Europeans it was the most obvious and natural thing in the world to make use of the dimension of movement, in other words gestures and the dance. Many non-European cultures enjoy not merely a rich verbal and musical tradition but also a long tradition of movement and dance. Many of these attempts degenerated into a self-conscious folksiness, and thus were unable to exert any decisive influence on the liturgy. But the message to the West was clear: for non-Europeans the dimension of movement and the language of the body belonged to the expression of faith in action.

The question arises whether western Christians are really any different. Is not bodiliness, the fact and awareness of being embodied, constitutive for human self-realisation? As early as the end of the 1950s there grew up a generation, one-sidedly called the beat generation, which distinguished itself above all by its forms of expression, with the combination of music and movement uniquely personified in Elvis Presley. Western man's bodily nature seemed suddenly to be breaking free of the chains that had held it bound for centuries. An entire generation acquired what in the truest sense was a new feeling for movement and for their own bodies. (The question arises here to what extent what has been termed the 'sexual revolution' played a part in this.) The Christian churches could not ignore this phenomenon but had to come to grips with it and ask themselves whether there now existed a possibility of renewal.

Understandably it was the American churches that were in the van of this process of rediscovery. One of many indications of this that could be mentioned was the enormous popularity of Sydney Carter's song 'Lord of the Dance' which took up a primitive Christian biblical theme, Christ as 'Lord of the Dance':

> Dance, then, wherever you may be,
> I am the Lord of the Dance, said he,
> And I'll lead you all, wherever you may be,
> And I'll lead you all in the Dance, said he.

It was in the first place the student Christian movements of America and Europe that in the 1960s not merely discovered but actually introduced the dimension of movement into their forms of worship. These services were often the expression of a genuine commitment with regard to both Church and world. The liturgy had not merely to be contemporary but to

be relevant too. People could not just sit there and mutter their way through the prayers: what was wanted was a mature participation, activity, the liturgy as an experience involving the entire human being.

In addition, the North Americans started with the advantage of having had for some generations in the black churches a tradition of movement united to worship. Gospel spirituals, such as 'He's got the whole world in his hands', are hardly conceivable or performable without movement. Well known, too, are the numerous smaller bodies—revivalist churches, Pentecostalists, among others—whose use of movement in worship even today characterises their image.

From the 1960s onwards the dimension of play and movement in the celebration of the liturgy was powerfully promoted in the churches of North America. The Harvard theologian Harvey Cox tackled the subject in his well-known book *The Feast of Fools* (Cambridge, Mass., 1969) and contributed to a revaluation of the liturgy throughout the world as a community celebration. An Episcopalian pastor in New York even rebuilt his church in the form of a theatre in order to enable his congregation, consisting largely of people engaged in that profession and in the arts generally, to feel more at home. As far as the Catholic Church is concerned, joy in experimentation with the dimension of movement is somewhat more subdued, especially when the official form of worship is involved. Nevertheless the liturgical gestures used by the charismatic movement, such as the stretching out of the hands or the raising of the eyes to heaven, show that ordinary Christians are capable of appreciating a greater share in this dimension of movement.

The greatest willingness to experiment is undoubtedly shown by the various 'underground' parishes and communities which are able to allow themselves a greater liturgical freedom.

As far as European countries are concerned, a certain openness towards the dimension of movement is first of all to be noted in the case of the Anglican Church. If progress in this country is somewhat laborious, this is in the first place to be ascribed to the fact that the existing forms of Anglo-Saxon dance culture, for example the ballet, can be not very helpful. 'Already the "ballet", as such, is a form of dance which has freed itself from its roots; a game, "no longer in the service of God and of nature, but of princes",' was the opinion of Gerardus van der Leeuw.[9]

It is only possible to speak of a genuine breakthrough in the dimension of movement when we consider the most recent developments within the German Evangelical Church in the Federal Republic. Within the context of a liturgical vigil at the Düsseldorf Kirchentag of 1973 it was able to mount a splendid attempt to bring the dimension of movement into the centre of the liturgy.[10] Thousands danced to songs like 'He's got the whole world in his hands' and to a setting of the Our Father that used calypso

rhythms. Among those present at this event was the general secretary of the World Council of Churches, Dr Philip Potter. This celebration was the signal for numerous congregations throughout the country to stage their own liturgical vigils. The development gained ground. At Kirchentage above all the introduction of elements of play into services of worship has become something taken completely for granted.

While the Catholic Church is in theory completely open to liturgical creativity, in practice it is more reserved and cautious. Nevertheless an openness to the playful dimension of the liturgy has slowly come about, even though still far distant from what Hugo Rahner had in mind, as for example at the most recent Katholikentage.

The Catholic Church of the Netherlands is among those in Europe that takes the greatest delight in expression. Here one can gain the impression that what other countries approve in theory is put into practice. In Antwerp in 1971 the journal *Tijdschrift voor Liturgie* organised, with substantial Dutch participation, the only liturgical congress to concern itself exclusively with the question of the bodily dimension of the liturgy and the role of movement in it.[11]

Finally we should recall the forms of liturgical expression adopted by the many small groups and communities that over the past fifteen years have sprung up everywhere in Europe. Many of these have been inspired by the liturgy of the Taizé community, and every year hundreds of young people (though not young people alone) make their way from all over Europe to this village in Burgundy. While various opinions are possible about the significance of such gatherings, what is clear is that without music and movement the experience of community is hardly conceivable and that without community the Church is hardly possible. At Taizé what emerges most clearly is that movement is a fundamental expression of a praying community as well as of worship. The wealth of ideas generated by small groups shows how general and widespread is the need of the individual Christian for a living form of worship.

What is the significance of the rediscovery of the dimension of movement for the Christian liturgy of today and for the future? Like Guardini, liturgical manuals point out that the liturgy possesses a number of traditional gestures of prayer that bear a 'symbolic' character. The movement of renewal has so far only one as far as breathing new life into these signs and symbols and making them understandable once more. Such attempts will always remain an effort, since most of these gestures do not provide a suitable expression of the feelings of the praying community. At most the sign of the cross can be regarded as in general use. The question arises whether people today and the world of today do not need other and newer symbols of prayer and also of gesture. The extent to which the dimension of movement has up till now been neglected is shown by the

fact that the search for new hymns and new texts has become something taken for granted.

At least as far as the churches outside Europe are concerned, the search for symbolic gestures that are more in keeping with the times has become an urgent necessity. In view of the unmistakable Western shape of the liturgy, it is only slowly that Asiatic and African churches in particular are able to discover new forms. Beyond the fact that in these countries the clergy have received a fundamentally Western training, what are lacking are the necessary research and investigations in the fields of the history of culture and of comparative philosophy and theology. These are the presupposition for significant experimentation. The introduction of new liturgical symbols is not, after all, something that can take place overnight. A lot of painstaking detailed work is needed to discover and develop them. In this respect the Indian sub-continent may form an exception, since it already enjoys a highly developed artistic system of gesture.[12] What is important in all these efforts is that the people play their part in the process of discovery. Outside as well as inside Europe, liturgy is no longer something that can be imposed from above.

In a certain sense this whole problem is more difficult for the Churches of Europe and North America. The appearance of the liturgy unequivocally shows the centuries of suppression of movement and of liturgical dance. Unlike the case of the Churches of Asia and Africa, there is no continuing tradition of religious dance which could possibly be drawn on to provide new gestures for Christian prayer. But in our view the need is even greater. The beat generation has in the meantime given way to the disco generation, but there is no slackening of the pressing need for movement. It is continually becoming richer in ideas, even if often more chaotic. Nevertheless any visitor to a modern discothèque can confirm that the need for gestures suitable for worship is more urgent today than ever before in the history of Christianity.

The question arises both for liturgical experts and for the study of liturgy whether the liturgy is in itself capable of development. Here it is less a matter of a particular understanding of liturgy as the manner in which this is to be expressed. Every understanding of the liturgy, after all, takes as its starting point the idea that God is calling his entire people and that the entire people answer him. How are they to do this except by means of word, music and gesture?

If the liturgy is capable of development, then the consequence must be drawn that a systematic search for new forms in keeping with the times—experimentation in the best sense of the word—must be actively encouraged. Liturgical institutes should be centres of creativity and not just serve historical research exclusively. The liturgy must enter into a dialogue with the world of today and with contemporary man if it wishes to

be and remain the relevant sign of Christ's act of redemption. Church music and liturgical language have both for a long time been in the foreground of renewal. Perhaps the dimension of movement has now reached the point where the liturgy can really become a complete expression of the faith of the whole human being.

Translated by Robert Nowell

Notes

1. In connection with the whole complex of questions dealt with here the author will, it is hoped, be allowed to draw attention to the fruit of many years' work he has devoted to this field: *Spielende Liturgie—Bewegung neben Wort und Ton im Gottesdienst am Beispiel des Vaterunsers* (Freiburg/Basle/Vienna 1977). This includes a full bibliography of the subject.

2. *Von heiligen Zeichen* (Mainz 1927: 1963 edition) p. 8.

3. *The Spirit of the Liturgy* (in one volume, preceded by *The Church and the Catholic*) (London 1935) p. 168.

4. J. A. Jungmann *Liturgische Erneuerung—Rückblick und Ausblick* (Kevelaer 1962) p. 17.

5. See *Spielende Liturgie* pp. 117-135, especially pp. 118-120.

6. Gerardus van der Leeuw *Sacred and Profane Beauty: The Holy in Art* (London 1963) p. 66.

7. *Eranos-Jahrbuch* 1948 (Zürich 1948), XVI pp. 11-87.

8. Cf. J. G. Davies (ed.), *Worship and Dance* (Birmingham 1975) pp. 22-28.

9. *Sacred and Profane Beauty,* quoted in note 6, at p. 53.

10. A full report is to be found in *Liturgische Nacht—ein Werkbuch Jugenddienst,* edited by the *Arbeitskreis für Gottesdienst und Kommunikation* (Wuppertal 1974).

11. *Tijdschrift voor Liturgie* 56 (1972).

12. See A. R. Sequeira *Klassische indische Tanzkunst und christliche Verkündigung* (Munich dissertation 1970) (*Freiburger Theologische Studien* 109) (Freiburg/Basle/Vienna 1978).

Contributors

ENRIQUE DUSSEL was born in 1934 in Mendoza (Argentina). He has a degree in theology and doctorates in philosophy and history. He is professor at the Free University of Mexico and in the Department of Religious Sciences in the Ibero-American University. He is also president of the Commission of Studies of the Church in Latin America (CEHILA). He took part in the Ecumenical Dialogue of Third World theologians in Dar-es-Salaam, Accra and Sri Lanka. His recent works include the following: *Desintegracion de la cristiandad y liberacion* (Salamanca 1978); *Filosofia de la liberacion* (Mexico 1977); *History of the Church in Latin America* (Grand Rapids 1979); *Ethics and Theology of Liberation* (New York 1978); *Los obispos latinoamericanos y la liberacion del pobre (1504-1620)* (Mexico 1979); *De Medellin a Puebla (1968-1979)* (Mexico 1979).

MICHAEL PAUL GALLAGHER, SJ, was born in 1939, and entered the Jesuits in 1961. He is lecturer in Modern English and American Literature, University College, Dublin (National University of Ireland). He has written literary criticism mainly in the area of contemporary fiction. He is also film critic for *Studies*. He was recently allowed a sabbatical year in order to study developments in the theology of atheism and to link these with modern literature.

BERNARD M. HUIJBERS, composer of Dutch liturgical music, was born in Rotterdam in 1922. After studying philosophy, theology and music he became a teacher of music and choir master at the Ignatius College in Amsterdam. He was later appointed teacher of liturgy at the Conservatory in Amsterdam and at the School for Church Music in Utrecht. One of the founders of the study group Universa Laus, he has lectured and published in many countries.

JEAN-PIERRE JOSSUA, OP, was born in 1930 in Paris, obtained a doctorate in theology in 1968, was professor at Le Saulchoir, and since 1971 he has been professor at the Institut catholique of Paris. His publications include: *Journal théologique* I (1976) and II (1978); *Un Homme cherche Dieu* (1979).

CONSTANTIN KALOKYRIS, full professor of Byzantine Archaeology at the Theological Faculty of the University of Salonica, was born in Crete, Greece. He studied theology, philology and Christian and Byzantine archaeology at the universities of Athens, Paris, Erlangen and München and started his career as curator in the archaeological service in Crete and chief of the same service in Piraeus and Islands. He has lectured in universities in USA, Russia, Italy, Germany, Austria, Lebanon, Syria, Australia and other places. Prof. Kalokyris has carried out excavations and undertook restoration work in Crete and in the Aegean Islands. His publications include: *Mt. Athos, Themes of archaeology and art* (Athens 1963); *Introduction to Christian and byzantine archaeology* (Salonica 1970); *The Essence of Orthodox Iconography* (in English) (Brookline, Mass. 1971); *The painting in Orthodoxy* (Salonica 1972); *Church Buildings and Modern Art* (Salonica 1978).

AIDAN KAVANAGH, OSB, is a monk of St Meinrad Archabbey in Indiana, USA, and a graduate of the University of Ottawa, Canada, and the Theologische Fakultät, Trier, West Germany. For eight years he was director of the Graduate Programme in Liturgical Studies at the University of Notre Dame before becoming Professor of Liturgies, the Divinity School, Yale University. An associate editor of *Worship* and *Studia Liturgica,* he is author of: *The Concept of Eucharistic Memorial in the Canon Revisions of Thomas Cranmer* (1963) and *The Shape of Baptism: The Rite of Christian Initiation* (1978), together with numerous essays in many journals.

BOKA DI MPASI LONDI, SJ, was born in Zaire and studied theology at Louvain and at the Gregorian University, Rome. He teaches at Mayidi Seminary in Zaire, is a spiritual director at the Propaganda in Rome and is editor-in-chief of the Christian review *Telema* ('Get up and Walk'). He is also a visiting professor at Lumen Vitae in Brussels. He is the author and composer of the national anthems of the Congo (1960) and of Zaire (1971) and has translated two hundred and fifty hymns of the Kimbanguist Church from Kikongo into French, published in Kinshasa in 1960. He has also written articles in *Orientierung, Stimmen der Zeit, Lumen Vitae* and *Telema.*

LUIS MALDONADO was born in Madrid in 1930, and was ordained priest for the Archdiocese of Madrid in 1954. He is now lecturer in Pastoral Liturgy at the Pontifical University of Salamanca and Director of the Higher Institute of Pastoral Theology at the same university.

ADRIEN NOCENT, OSB, is a monk of the abbey of Maredsous, Belgium. Born in 1913, he has done special studies at the Institut de Liturgie in Paris, has been professor for ten years at the catechetical institute of Lumen Vitae in Brussels, and has been professor at the Pontifical Institute of Liturgy, San Anselmo, Rome, since its foundation in 1961. He has published numerous articles above all in liturgical reviews and has contributed to such joint works as *L'Eglise en prière*. His own books include *The Liturgical Year* (4 vols.).

A. RONALD SEQUEIRA was born in Bombay, India, in 1937. He was lecturer in the social sciences, Bombay University between 1962-64. He gained doctorate at Munich University under Karl Rahner (1970) with a dissertation on the classical Indian dance and Christian proclamation. He has lectured on eastern religions and liturgy at Heerlen theological college, Netherlands, 1969-72, and on history of religion at the Protestant theological faculty, Bochum University, West Germany, 1974-75. At the moment he is lecturer in comparative cultural studies at Maastricht and in the history of religion at Eindhoven, both in the Netherlands. His publications include: *Spielende Liturgie—Bewegung neben Wort und Ton im Gottesdienst am Beispiel des Vaterunsers* (1977) and *Klassische indische Tanzkunst und christliche Verkündigung* (1970).

CRISPINO VALENZIANO, born in Cefalù, Sicily, in 1932 and ordained in 1954, is a Doctor of Philosophy in the Gregorian University of Rome and the state university of Genoa and has specialised in anthropology at the Facult of Catholic Theology in Strasbourg and the Sorbonne in Paris. After ten years' university teaching of philosophy and anthropology he became in 1976 Dean of the St John the Evangelist Theological Institute at Palermo. Among many extra-mural appointments he works at ecumenical exchanges between the churches of Sicily and the Greek church. Editor since 1974 of *Ho Theologos: Cultura Cristiana di Sicilia,* he contributes articles on anthropology and theology to various reviews and has among his publications: *Limiti della cristologia kierkegaardiana* (1965); *Religiosità popolare e pastorale liturgica* (1978); *L'ambone, icone della Risurrezione* (1978); *La basilica cattedrale di Cefalù nel periodo normanno* (1979) (also translated into French); *Sacramenta* (1980).

CYRILLE VOGEL, is a lecturer at the *Université des Sciences Humaines,* Strasbourg. His recent publications include: *Introduction aux sources de l'histoire du culte chrétien au moyen âge* (2nd ed. Turin 1975); *Ordinations inconsistantes et caractère inadmissible* (Turin 1978); *Les 'libri paenitentiales'* (Turnhout, Belgium).

DECLARATION OF CONCILIUM

We, directors of the international review of theology *Concilium,* do not see any well-founded reason not to consider our colleague Hans Küng as a Catholic theologian.

We shall, therefore, press to have the judgment reconsidered.

In addition we ask with emphasis that the ecclesiastical procedure in religious matters will respect the commonly established rules of human rights.

Professor Jürgen Moltmann of Tübingen has indicated that he wishes to be associated with the fuller statement of the editorial directors published in our issue No. 10 1979.